IMAGES
of America

SOUTH PHILADELPHIA'S LITTLE ITALY AND 9TH STREET ITALIAN MARKET

IMAGES
of America

SOUTH PHILADELPHIA'S LITTLE ITALY AND 9TH STREET ITALIAN MARKET

Michael DiPilla

ARCADIA
PUBLISHING

Published by Arcadia Publishing
Charleston, South Carolina

Library of Congress Control Number: 2016930462

For all general information, please contact Arcadia Publishing:
Telephone 843-853-2070
Fax 843-853-0044
E-mail sales@arcadiapublishing.com
For customer service and orders:
Toll-Free 1-888-313-2665

Visit us on the Internet at www.arcadiapublishing.com

*This book is dedicated to my uncle Nicola Leone, a photographer and
artist in Philadelphia; Rosemary Raggio Guano Toner Hodges Guarelia,
who inspired my interest in the early Italians of Genovese descent; and
especially to my mother, an Italian immigrant who worked so hard
in the sweatshops of Philadelphia and inspired me to work hard.*

CONTENTS

ACKNOWLEDGMENTS

I would like to begin by giving recognition to the work of Nicholas DeCarlo and Giuseppe Gaeta, who were the leading photographers of Little Italy Philadelphia at the beginning of the 20th century. They left behind an extensive photographic record, and somehow many of the photographs have never been seen before. Fortunately, the Baldi family preserved the original images so we all can all enjoy them today. Other images are from my personal collection, as my family were also photographers and maintained an extensive collection as well. Special thanks go to Lisa Nigro Petragnani and Dante Molino.

Appreciation is also given to the Free Library of Philadelphia, the New York Public Library, and the Historical Society of Pennsylvania, who maintain historical documentation and newspapers of this period that I have been able to research to provide the historical content.

INTRODUCTION

What does it mean to be Italian? Here we are in Little Italy, where many Italians have lived for over 200 years. But who are they? From where does the name derive?

Well, on my recent trip to Catanzaro, I saw a sign that read "qui n'acque il nome Italia." Here's where the name "Italy" was born. Historically, it all began in Southern Italy, at the southernmost point. The name comes from the word *Italoi*, a term the Greeks used to refer to the Vituli (or Viteli) calf worshipers. Until the beginning of the fifth century BC, "Italy" indicated only Calabria.

Roman Italy was created officially by the Roman emperor Augustus, who named it Italia, the first time in history that the Italian peninsula—the Boot, as we so fondly call it—was united under the same name.

Along the way, Italy separated into many separate city-states. By the time of the American Revolution, Thomas Paine, in his publication the *Pennsylvania Magazine*, identifies the various Italian states as: the Austrian dominions in Italy (Piedmont-Milan), Naples and Sicily (Due Sicilie), the dominions of Sardinia (Genoa), the dominions of Venice, and the Pope's dominions (Rome).

Italians have been a part of the scene in Philadelphia since Colonial times. The first person to see to the Delaware River was Giovanni da Verrazano in 1524. In 1665, a group of Waldensians (Italian Protestants) came to area along the Delaware River seeking religious asylum. The Englishman William Penn, a Quaker who believed in religious freedom for all, had traveled to Italy prior to his arrival in 1682.

In the 1700s, Philadelphia was the largest English-speaking city outside of London. It grew to become the capital of Colonial America. It is not a wonder there were over 100 Italians in Philadelphia during this period.

When one thinks of Little Italy, thoughts of the Italian restaurant, the cigars, the Italian sausage, the Italian wine, and Italian imports like vermicelli, parmesan, and olive oil all come to mind. It is a neighborhood with Catholic churches where the local Italians can worship and celebrate their births and weddings; a place where one can get espresso, orzato, and gelato; and a neighborhood where artists, musicians, doctors, politicians, and influential businessmen from the city live. In the late 1700s, Philadelphia had the first Little Italy in America. The boundaries of Little Italy were basically the original city limits, from Callowhill Street to South Street and Front (First) Street to Fourth Street. There was an Italian dance studio, fireworks, and even the circus with Italian performers. In the early 1800s, there was still a smattering of Italians in the city. The Old City was separated from the area known today as Society Hill by Dock's Creek. A drawbridge existed on Front Street where the current Korean War Veterans memorial exists.

Lorenzo DaPonte, a librettist for Mozart, landed in Philadelphia about 1800. From 1800 to 1819, over 150 Italians are recorded as coming into the Port of Philadelphia. In the 1830s, Joseph Bonaparte sought political asylum in Philadelphia and lived off Ninth and Spruce Streets. As time progressed, a group of Italians was living in the area from Sixth to Eighth Streets along Lombard Street. There were Italian artists living on Fifth and Pine Streets.

The earliest arrivals of course were the English. They controlled the area in Center City up to Spruce Street. During the period of mass migration in the 1880s, Russian and Romanian Jews came to Philadelphia, they filled in the next area from Spruce Street to Bainbridge Street. The Italians filled the area from there up to Carpenter Street. Sixth and Fitzwater Streets saw a battle for supremacy between Jews and Italians.

Coming in from the Delaware River, the Polish filled in the first few blocks, where early Swedes lived. Then, again, the Jewish occupied the blocks from Fourth to Sixth Street. Finally, the Italians ran from Sixth to Tenth Streets, then later Eleventh Street, and south to Washington Avenue. They crossed Washington Avenue and filled in up to Federal Street by the beginning of the 20th century and were then limited by the cemetery and prison where Ninth Street, Federal Street, and Passyunk Avenue all meet.

The first Italian in what would become Little Italy was Giuseppe Marbello, who lived at Passyunk Avenue and Catherine Street as early as 1798. The neighborhood of Little Italy grew around Montrose Street, which housed the first Italian church and the Cuneo restaurant. Little Italy was originally called "Irish Town" in the 1840s, when Andrew Cuneo arrived and opened a restaurant on Montrose Street. By 1852, there were enough Italians to form the first Italian Catholic church, St. Mary Magdalen de Pazzi. During this period, many well-to-do Italians left Italy for political reasons (known as *fuoriusciti*) and came to Philadelphia as artisans, bankers, merchants, and musicians. The Italians became centered in the area of Seventh and Montrose Streets. In 1847, when Andrew Cuneo arrived on Marriot Street (now Montrose), he said he was in Irish Town. During the election of 1853, there were reports of ballot stuffing by Italians. Two years after the Civil War, the Italians organized their first society, Societa D'Unione e Fratellanza. They were based at Columbus Hall on Eighth Street. Most of these immigrants were from the northern cities of Genoa and Florence. There was only a small group from port cities of Palermo and Napoli. As early as 1873, local newspapers spoke of an Italian Quarter at Eighth and Carpenter Streets. By 1880, the number of Italians born in Philadelphia had risen to 1,600. During this time, mass migration increased as a result of the Italian Unification. By 1884, Little Italy had spread from Seventh to Eighth Streets and Bainbridge Street to Washington Avenue. Washington Avenue became known as the "Rubicon," because it was not advisable to go beyond this street due to hostilities with other nationalities. However, by 1906, Little Italy had extended to Federal Street, where the Moyamensing Prison and Lafayette Cemetery formed a boundary.

One

THE CITY OF PHILADELPHIA

Philadelphia was the largest city in early America; with the building of the Erie Canal, it slipped to second. So it is not a wonder that the city had the second-largest Italian population in America. Most Italians lived in South Philadelphia in the area centered on Eighth and Christian Streets. During this period, there were large concentrations from the provinces of Campobasso, Chieti, Salerno, Palermo, and Catanzaro. It is difficult to determine the exact number of Italians at the beginning of the 20th century. According to the locals, it would be impossible for the census to accurately determine the number of Italians in Philadelphia. Only a few spoke English. The majority of Italians came from Abruzzi (Molise and Abruzzo) and Sicily. A good number of the earliest immigrants were also from Tuscany and Genoa. They lived in an area the Americans called "Little Italy." Early newspapers referred to the area as the Italian Quarter or the Italian Colony. What caused the population of Italians to grow during this period? The principal cause of the exodus was paradoxically the unification of Italy in 1861. Prior to this time, Italy was made up of city-states. The three largest were the Kingdom of Sardinia, with its capital in Turin, the Papal States around Rome, and the Two Sicilies (Kingdom of Naples) in the south of Italy, with its headquarters in Naples. The first revolution in the Italian states occurred in 1848. Intellectuals and agitators desired a liberal government. Unfortunately, they were not successful in their attempts to unify. It would not be until 1861 that Italy finally became unified again. The new capital of Rome and the Papal States were not added until 1871. As early as the 1850s, some large groups of Northern Italian merchants from Genoa and Florence began to leave Italy. The mass migration would be the result of not only the unification of Italy but of the new immigration law that Lincoln was forced to pass as a consequence of the Civil War. In 1864, "An Act to Encourage Immigration" opened up the borders. Many western states and the railroads spent lots of money to advertise the benefits of the Promised Land. American contractors sought out Italian *padroni* to obtain the cheapest possible labor. The padroni helped to arrange employment and bring many immigrants to this country. Under the unification in Italy, harsh taxes were imposed on the Southern Italians causing them to flee. The Piedmonts, who gained control in Southern Italy from the Bourbons, imposed harsh taxes on the south of Italy up to a rate of 30 percent. Since Italy was recently unified, many of these illiterate peasants did not even know that the country was unified and still clung to their original states, so people still hold on their Abbruzzese, Calabrase, Neapolitan, and Sicilian origins. In 1908, there was a terrible earthquake in Messina and Reggio Calabria, driving more departures.

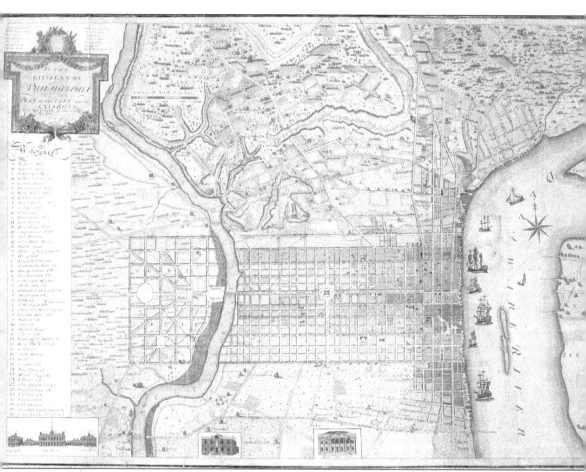

This map of Philadelphia in 1802 shows the area in South Philadelphia where Little Italy would develop. The pond off the intersection of Federal and Passyunk Roads would later become the site of the Lafayette Cemetery, and today it is location of the Capitolo Playground. One should note the Federal Road that ran from the Delaware to the Schuylkill River. It was designed to connect the Navy yard with the federal arsenal near Gray's Ferry. (Author's collection.)

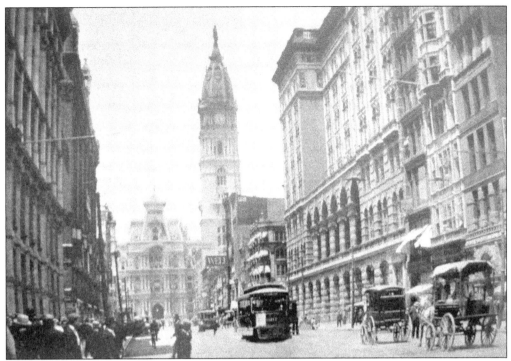

City hall is seen from Tenth and Market Streets. Note Reading Terminal on the right. The city was laid out like a Roman city, with the two main arteries being Broad Street (the *cardo maximus*, or north-south street) and Market Street (the *decumanus maximus*, or east-to-west street). They crossed at Center Square. By 1897, city hall was completed in this spot. In the 1770s, the square was the site of early horse races. (Author's collection.)

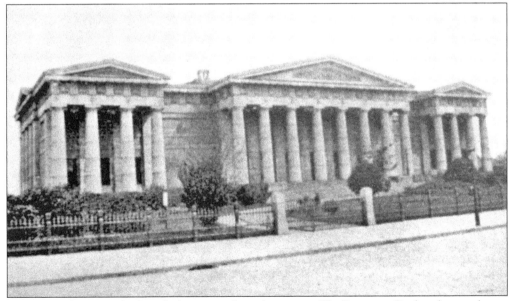

Ridgeway Library was built with the money from the estate of Dr. Benjamin Rush, a famous doctor during the yellow fever epidemic of Colonial Philadelphia. This free library was built at Broad and Christian Streets and was available to many of the immigrants. (Author's collection.)

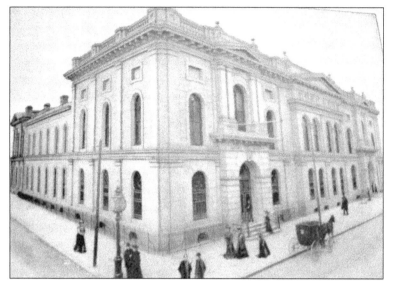

The Philadelphia Savings Fund Society (PSFS) Bank was in the 700 block of Walnut Street. The PSFS Bank would move later in the 1930s to Twelfth and Market Streets, where it became the first air-conditioned building of its size in the United States. (Author's collection.)

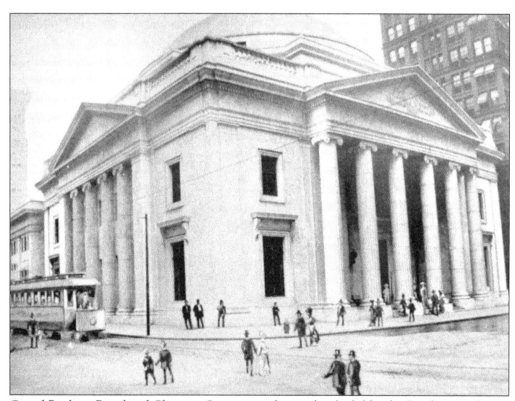

Girard Bank, at Broad and Chestnut Streets, was designed to look like the Pantheon in Rome. An earlier bank, the Bank of Pennsylvania, also incorporated a cupola with an oculus. Unlike Rome, in Philadelphia, the oculus could not be kept open and was instead capped. Stephen Girard purchased the First Bank of the United States in 1811 when its charter ran out. The First Bank of the United States had been designed to look like the Maison Carrée, a Roman temple in Nîmes, France, and one of Thomas Jefferson's favorite buildings. (Author's collection.)

Two

MEDICINE

Italian Immigrants were not all literate or able to speak English fluently. The use of local doctors in the community was of great importance. The first recorded Italian doctor in Philadelphia was Dr. Joseph Batacchi in 1763. The *Pennsylvania Gazette* of August 29, 1765, records:

> To the PUBLIC, JUST arrived in this City, JOSEPH BATACCHI, an Italian Surgeon, regularly bred to Surgery in the best Hospitals of Italy, and has practiced that noble and useful Art in different Parts of Europe with great Success; and a Desire to see the American World led him to this Port, where he shall be glad to have frequent Opportunities of relieving those whom Sickness of Accidents hath rendered Objects of distress, besides the usual Branches of Surgery, in which long Practice and Experience hath confirmed his Studies, he proposes to practice Physic in it is various Branches; he also removes the Scurvy, and all malignant Humours from the Gums so destructive to the Teeth, and the real Cause of the Tooth ache; and cleans and polishes the most foul, so as to render them white and fair. He may be spoke with at his lodgings, at Mr. Steel, in Southwark, the second Door below Doctor Clarkson, and if required will wait on Gentlemen or others at their houses. N.B. He will give his Advice Gratis to the Poor.

Southwark was the area just south of South Street. Dr. Batacchi was a friend of Dr. Filippo Mazzei and was from Tuscany. They both met in Florence in the 1750s before Mazzei went on to London, where he would later meet Franklin and Jefferson.

One of the earliest doctors in Little Italy was Dr. Domenic Pignatelli, who is recorded as being here as early as 1871. Pignatelli was from Monteruduni in what was then the Abruzzi. Italians felt more comfortable going to doctors who spoke the same language. In 1902, Dr. Vincent Fabiani established an Italian hospital at the corner of Tenth and Christian Streets. Prior to this, many Italians went to Pennsylvania Hospital, just down the street from Little Italy at Eighth and Pine Streets. A news article from 1871 notes that Pignatelli was president of the Italian Beneficial Society, and based on a petition from Consul General Vito Viti, he remained in office until after the American centennial.

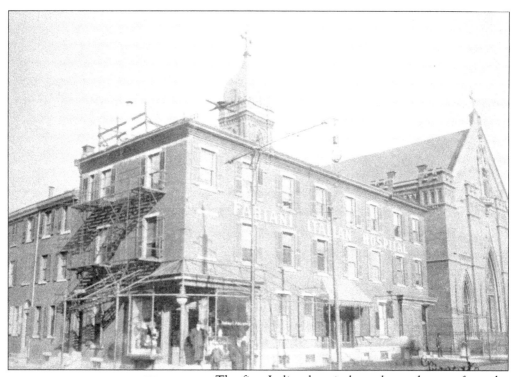

The first Italian hospital was located across from the Christian Street hospital on the 900 block of Christian Street. Note St. Paul's Church on the right, which would later become a church for the Italians. The private hospital opened in 1904. (Courtesy of Baldi family collection.)

One of the first doctors of the Italian community was Dr. Fabiani. He was born in San Pietro at Maida, Catanzaro, in 1864. He received his degree in surgical medicine at the University of Naples in 1889. (Courtesy of Baldi family collection.)

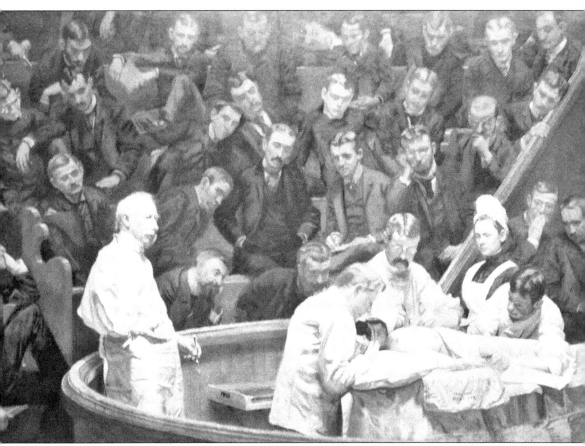

A famous painting depicts the Pennsylvania Hospital of Surgery. The surgeries were done in the main rotunda. Students could look down on the operations. Thomas Eakins did two pictures of Dr. Jacob DaCosta. Eakins was an artist who enjoyed visiting Little Italy. In his memoirs, he records his dinners in Little Italy and enjoying the local puppet shows. (Author's collection.)

The Methodist Episcopal Hospital was located at Broad Street between Wolf and Ritner Streets. When it was first built in 1892, there were not Italians in this part of Philadelphia. As Little Italy expanded south, this would be the birthplace of many Italian immigrants' children. (Author's collection.)

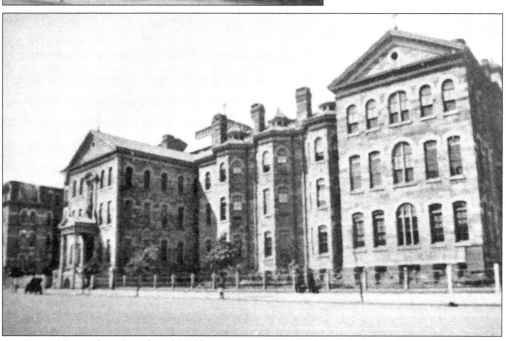

St. Agnes Hospital, at Broad and Mifflin Streets, was also the birthplace of many of the Italian immigrants' children. (Author's collection.)

The Italian dispensary was opened by the Society of Italian Immigrants at Tenth and Bainbridge Streets. The goal of the dispensary was to care for the immigrants arriving in the city long enough so that they could obtain citizenship. There was also a school that provided a course in US history and helped naturalize the immigrants who had arrived at the Port of Philadelphia. (Courtesy of Baldi family collection.)

Dr. Giovanni Feo, whose office was at 732 Montrose Street, was from Stella di Cilento in Salerno. He studied at the University of Naples and immigrated in 1900. Feo's office was just down the street from the Italian church St. Mary Magdalen de Pazzi. (Courtesy of Baldi family collection.)

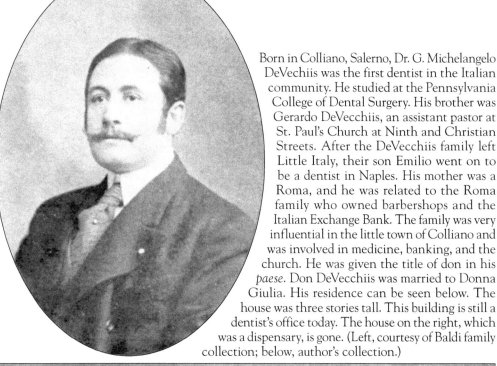

Born in Colliano, Salerno, Dr. G. Michelangelo DeVechiis was the first dentist in the Italian community. He studied at the Pennsylvania College of Dental Surgery. His brother was Gerardo DeVecchiis, an assistant pastor at St. Paul's Church at Ninth and Christian Streets. After the DeVecchiis family left Little Italy, their son Emilio went on to be a dentist in Naples. His mother was a Roma, and he was related to the Roma family who owned barbershops and the Italian Exchange Bank. The family was very influential in the little town of Colliano and was involved in medicine, banking, and the church. He was given the title of don in his *paese*. Don DeVecchiis was married to Donna Giulia. His residence can be seen below. The house was three stories tall. This building is still a dentist's office today. The house on the right, which was a dispensary, is gone. (Left, courtesy of Baldi family collection; below, author's collection.)

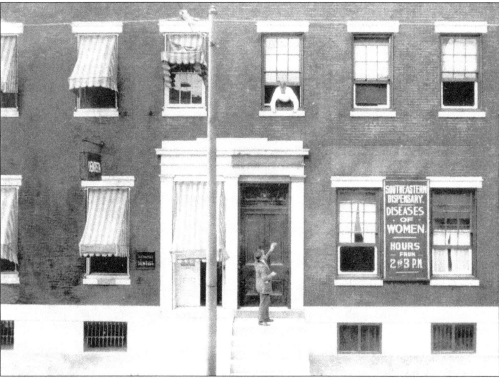

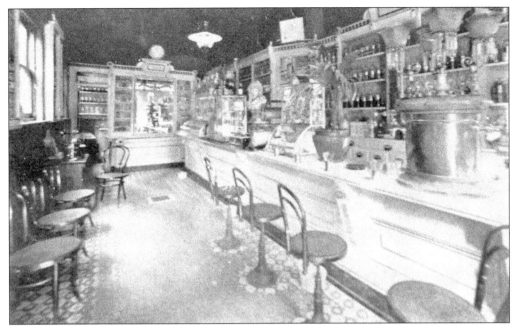

This pharmacy and soda fountain at 938 South Eighth Street was owned by Gennaro Tito Manlio. He was born at Montefalcione, Avellino, and opened this pharmacy in 1896. Carbonated water was considered to have medicinal uses, so it began to be flavored and sold at fountains like the one pictured. Manlio eventually moved his store to the corner of Eight and Carpenter Streets and was regarded as one of the most prominent pharmacists in the Italian quarter of the city by the National Association of Retail Druggists. (Courtesy of Baldi family collection.)

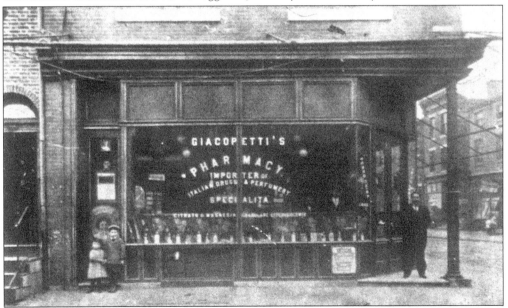

The Italian pharmacy of Guido Giacopetti was opened in April 1909 at the southeast corner of Sixth and Christian Streets. His specialty was *ferrochina* in powder and liquid. He sold it with a letter from the federal government in Washington. It was a fabrication of granular effervescent magnesium. (Courtesy of Baldi family collection.)

Vittorio Michelotti was the first Italian pharmacist in Philadelphia. He was born in Pisa in 1860 and immigrated in 1878. He started under Dr. Pignatelli. After several years of service to Dr. Pignatelli, in 1893, when a Dr. Hickman decided to retire, Michelotti bought the pharmacy. (Courtesy of Baldi family collection.)

Michelotti Pharmacy was at the corner of Eighth and Fitzwater Streets. The various bottles of medicine can be seen on the shelves in the background. On the left is Zymogide, an antiseptic and detergent. Notice the gas light fixtures. (Courtesy of Baldi family collection.)

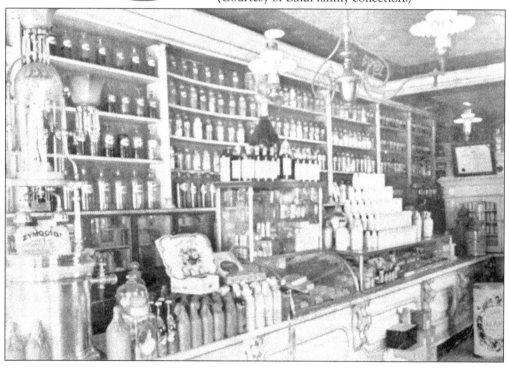

Three

PUBLISHING AND MEDIA

Italian newspapers appeared in Philadelphia as early as 1853 with *La Gazetta Italiana*. *Il Risorgimento* was published by Lorenzo Bozzelli in 1886. Bozzelli owned the bank at Seventh and Fitzwater Streets. In 1895, *La Voce della Colonia* was published by Frank Cerceo and Frank Catalano, both bankers. *La Voce del Popolo* was a daily paper published by Giuseppe DiSilvestro. This was succeeded by *La Libera Parolo*. There was also *Il Vesuvio*, the oldest Italian newspaper in Philadelphia, established in 1886 and published by Prof. F.J. Scannapieco. *Mastro Paolo* was a weekly put out by Giuseppe Bruno. However, the paper that had the longest run was *L'Opinione*, by Carlo Baldi, which started in 1905. By 1906, there were three Italian newspapers in Philadelphia. The major one was *L'Opinione*. Today's Italian paper, *Ciao*, is published by Baldi's descendant Gregory Jacovini.

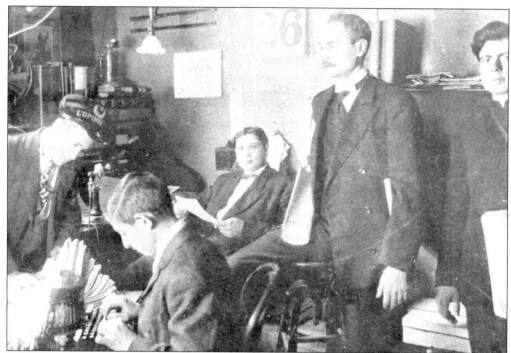

A typical day in the editing department is depicted above. The editors all met in the early morning. Then they went out to the station house, city hall, and other places to get the news. The director did not arrive until 11:00 a.m. He read the mail that the editing secretary had ready for him. At noon, the entire team went out to lunch. In the afternoon, the newspaper life intensified. At 3:00 in the morning, dispatchers joined in. They provided their information to the linotypes, and the linotypes issued the type, which could then be corrected. Editor Pietro Jacovini is seated in the center. He married Carlo Baldi's daughter Grazia. (Both, courtesy of Baldi family collection.)

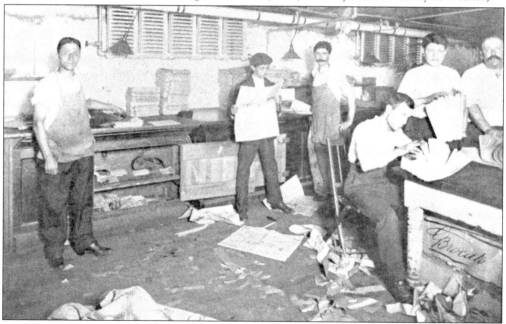

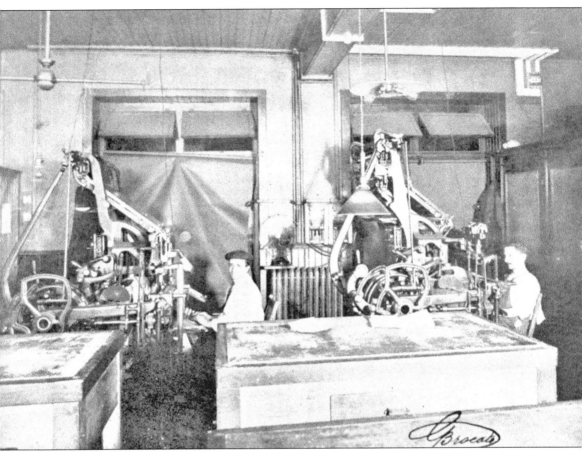

The linotype was the industry standard for newspapers. The name of the machine derives from that fact that an entire metal line of type could be composed at once. (Courtesy of Baldi family collection.)

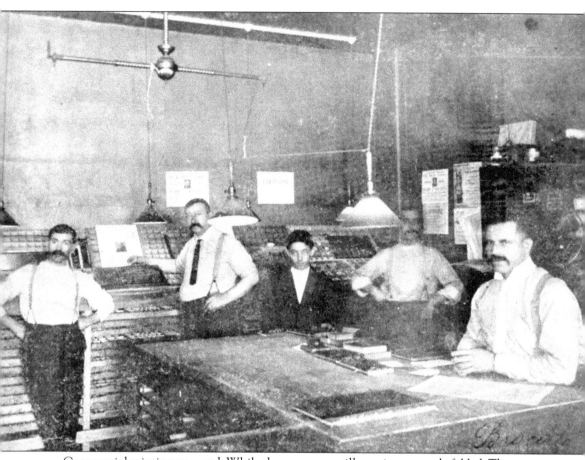

Commercial printing was used. While the paper was still wet, it was neatly folded. The paper was then sent out from the shipping department to many states in large postal envelopes. (Courtesy of Baldi family collection.)

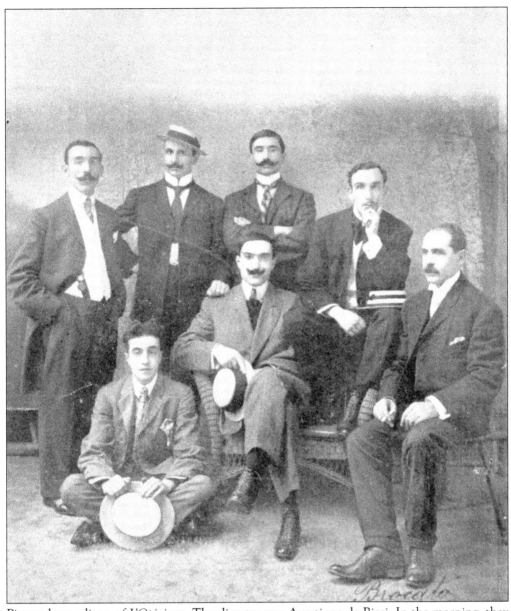

Pictured are editors of *L'Opinione*. The director was Agostinoe de Biasi. In the morning, they shared ideas, and then the paper unfolded with commentary and news stories. (Courtesy of Baldi family collection.)

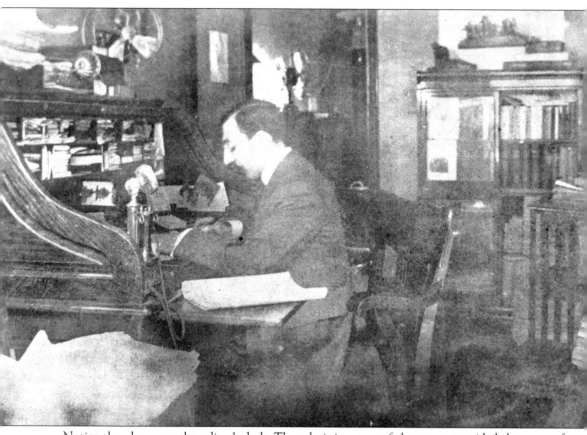

Notice the phone on the editor's desk. The administrators of the paper provided the news of Philadelphia. There was also an arts section, horoscope, and news on the movement of ships in the port. (Courtesy of Baldi family collection.)

Four

FOOD AND GROCERS

Italians have been known for their great food since the time of the Romans. Some accounts indicate that Marco Polo discovered pasta while in the Orient. However, it is recorded that the Romans used pasta in their daily cooking.

The first Italian-owned restaurant was opened in Philadelphia in 1784 by Vincent Pelosi. By 1890, there were at least seven restaurants in Little Italy. Jacob Arata was at 817 Fallon Street, the Campiglia Bros. (Frank and Joseph) restaurant was at 214 South Eighth Street. Antone Gagali was at 806 Christian Street, and Anthony Guiseppe's restaurant was at 741 South Eighth Street. Joseph Malatesta's restaurant was at 408 South Eighth Street; Anthony Marsca was at 753 South Eighth Street; and Domenico Nazzareno was at 722 Passyunk Avenue.

The local Italian community used olive oil and other imported products, and these were available to the community very early. The report by the Italian Department of Exports in 1883 shows that Philadelphia imported not only oil but also citrus fruits, wine, cork, and many other products. It should be noted that not only did the community import from Italy, it also exported crude oil and other items to Italy. One of the first producers of pasta in America lived here in Philadelphia. Giovanni Sartori, who was active in Philadelphia as early as 1794, opened the first spaghetti factory in the United States.

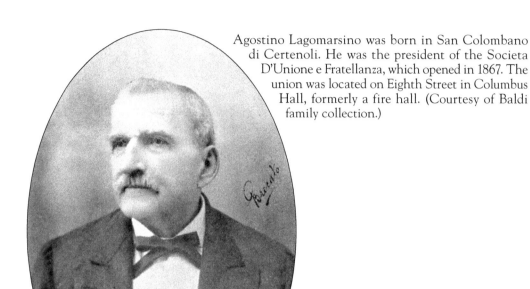

Agostino Lagomarsino was born in San Colombano di Certenoli. He was the president of the Societa D'Unione e Fratellanza, which opened in 1867. The union was located on Eighth Street in Columbus Hall, formerly a fire hall. (Courtesy of Baldi family collection.)

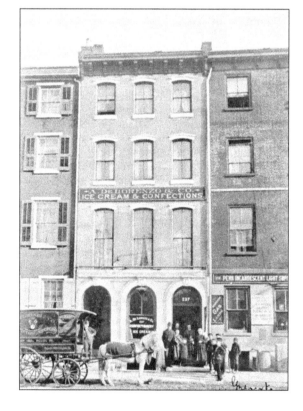

DeLorenzo & Company was located at 237 South Sixth Street. This property was valued at $15,000 in 1905. This factory made ice cream. There was also an ice cream saloon at 406–408 South Eighth Street where the most elite Americans and Italians could enjoy the taste of Angelo DeLorenzo's ice cream as well as drinks, sweets, chocolate, and *bomboniere* (gifts given for special occasions). Italian ice cream vendors came as early as 1786, when Vincenzo Pelosi began selling ice cream in Philadelphia. He was the owner of the Pennsylvania Coffee House. (Courtesy of Baldi family collection.)

Antonio Ferrigno ran a grocery store at 736–738 Fitzwater Street. He sold Lucca Oil, cheeses, and Ivory Soap pumice. He was a native of Casavelino, Salerno, and immigrated in 1872. (Courtesy of Baldi family collection.)

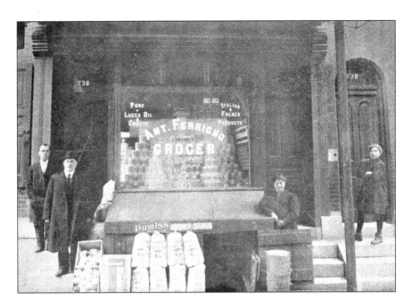

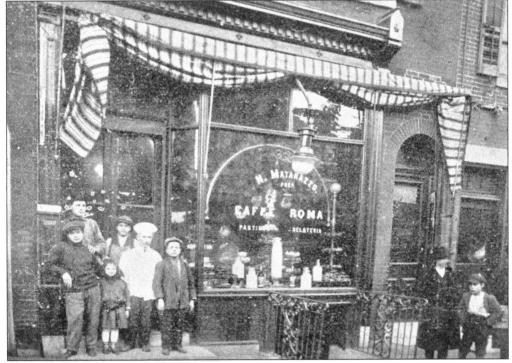

The Caffe Roma was a restaurant and pastry shop was owned by Nicola Matarazzo. The pastries are on display in the window. It was located at 831–833 Christian Street. It took orders for weddings, baptisms, and banquets and sent pastries to any part of the United States. The goodness of the sweets and the precise execution of the orders allowed the owners to not fear competition. (Courtesy of Baldi family collection.)

Maccheroni Pasta di Napoli was located at 747 South Seventh Street. The owner was born in Dentecane, Avellino, and immigrated in 1877. He worked for Franceso Cuneo, the most important factory at the time. He also worked for Guano e Raggio. With a small amount of money, he bought a machine and opened his store. Notice that there is a rooftop deck on this house. The house on the left was the first residence of Michele diPilla, the author's great-grandfather, who lived there in 1905 with his uncle Gaetano Anastasio, who sold meat. (Courtesy of Baldi family collection.)

Gennaro Pinto was a grocer at 921 South Ninth Street. He was from Casalvelino, Cilento, and immigrated in 1888. Note the trolley tracks and the fruit vendors on Ninth Street. Pinto Bros. is now a wholesale importer. Note the police officer's hat on the right. It looks like the traditional dome-shaped helmet of British bobby fame. (Courtesy of Baldi family collection.)

Italian Liquor & Beers, owned by Michele Martino, opened in 1890 at 1019 South Ninth Street. Martino was the only son of Diodato and Maria Celeste Tullio from San Giovanni in Galdo, Campobasso. He immigrated in 1879. (Courtesy of Baldi family collection.)

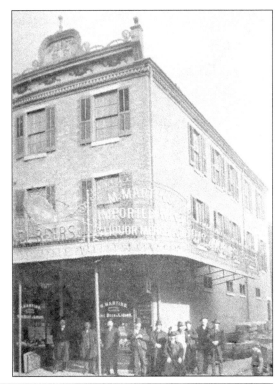

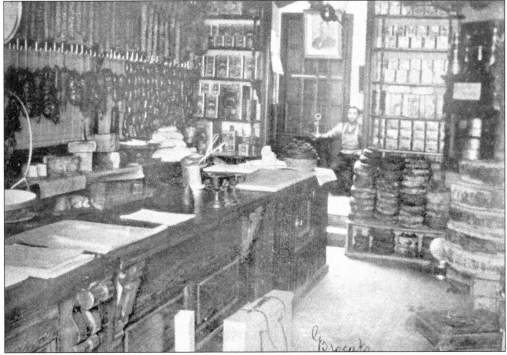

Giovanni Mase e Figlio (later Mase & Sons) was located at 766 South Eighth Street in the heart of Little Italy. It was the only business of its kind to compete with the grand salami makers of Italy. (Courtesy of Baldi family collection.)

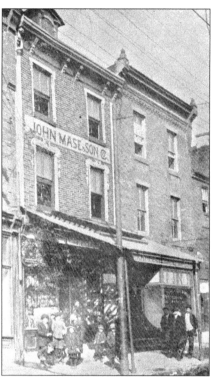

Pictured is the outside of Mase & Sons at 766 South Eighth Street. Mase would go on to own both 766 and 768 South Eighth Street. The author met with Giovanni Mase's granddaughter Olga. (Courtesy of Baldi family collection.)

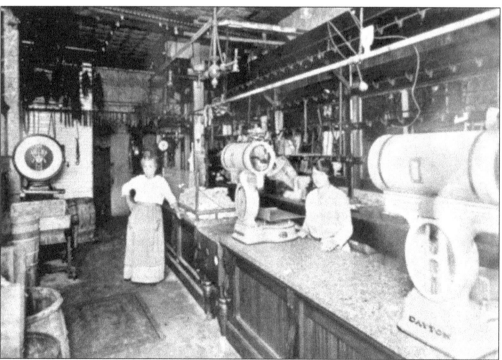

Here is the interior of Fiorella's Sausage Shop, which opened in 1892. Today, the store looks much as it did at the beginning of the 20th century. The original butcher block can still be scene in the store. (Courtesy of Fiorella family collection.)

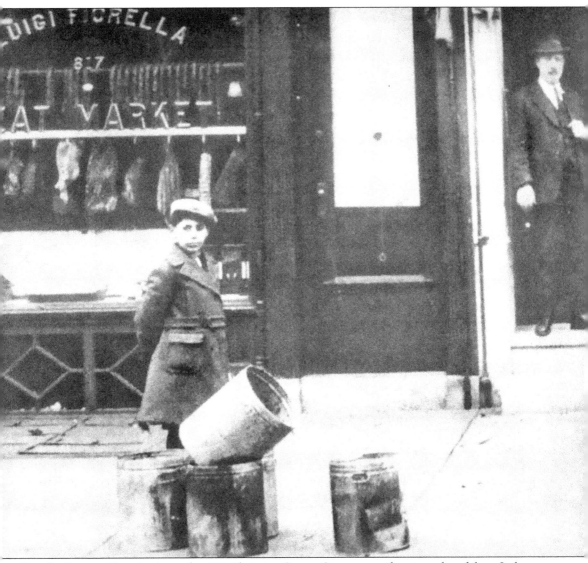

Fiorella Sausage Shop is pictured at 817 Christian Street. Sausage was first introduced from Italy by Antonio Vitali in 1772. He sold all types of sausages and indicated they could be boiled, fried, or eaten raw. (Courtesy of Fiorella family collection.)

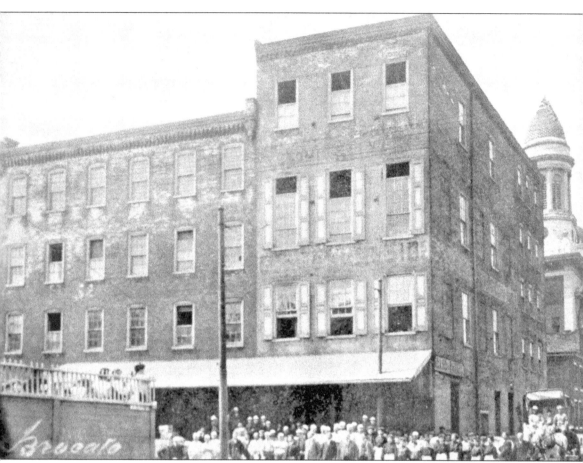

Guano e Raggio Macaroni Factory was at Seventh and Montrose Streets. Notice St. Mary Magdalen de Pazzi Church. Emmanuel Guano went on to receive a commendation from President Wilson. Antonio Raggio was in business with Pietro Cella in the 1873. Guano was from the Chiavari province of Genoa. Raggio was from Cabanna, Genoa. Both men are in the center area of the crowd in the photograph. Both were very prosperous and had homes in Atlantic City. (Courtesy of Baldi family collection.)

Five

ART, MUSIC, AND PHOTOGRAPHY

Many Italians have a great appreciation for music and art. As early as 1765, Giovanni Gualdo came to Philadelphia to entertain the community. In 1819, *The Italian Wife* was performed at the Chestnut Street Theatre. The Quakers, however, frowned on dancing and frivolity. Opera performances were enjoyed by the crowds and became songs they would hum as they walked about. This was frowned upon by the English speakers of the day, since the music was in Italian and the operagoers were not speaking or singing in English. In the 1870s, the pastor of Mary Magdalen Church wrote a play about the life of the Italian immigrant. In 1905, a play was written called *Little Italy*.

In 1876, Philadelphia hosted the celebration of the 100th anniversary of the founding of the United States. As part of this celebration, a world's fair was held in Fairmount Park. An entire series of buildings was constructed to house the collections. Memorial Hall was the main building. Italy, which had just been unified and established with its new capital in Rome, contributed over 300 paintings and sculptures. They were in the west end of the main building. Valuable, museum-quality cameos, mosaics, Venetian mirrors, and spun silk goods occupied six galleries in the Art Annex, along with sculptures from Rome, Florence, Milan, and Bologna.

Prospero Cortese immigrated to Philadelphia in 1882 at the age of 10. He was born in Marsciovetere in the province of Potenza. An accomplished violinist at 16, he returned to Italy and studied under the noted violinist Enrico Sansone, who was later the director of the Music Conservatory of Chicago. Cortese ran a music school at 919 Federal Street. (Courtesy of Baldi family collection.)

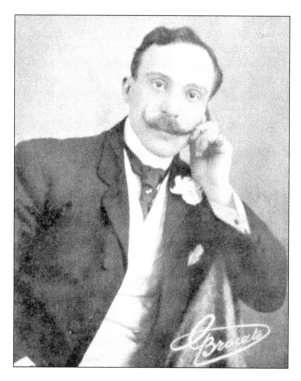

Giuseppe Brocato Gaeta was the famous photographer of the Italian community. His photographs are here as a tribute to his greatness. His studio was at 759 South Eighth Street. Brocato was from Cefaulu, Palermo. He came to American in 1901. (Courtesy of Baldi family collection.)

This is Verdi Hall, the Italian theater where many operas were performed. Verdi Hall could seat 700 people in its 3,200-square-foot facility. The building was made of cement and artificial stone and cost $45,000, or 225,000 lire. Giuseppe Perna worked with love to construct this building. (Courtesy of Baldi family collection.)

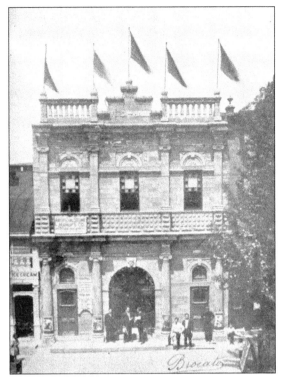

The famous tenor Ferruccio Giannini was dedicated to a purely Italian theater where Italians could come to enjoy productions by Italian artists. The theater was built at a cost of $50,000 at the time. Giuseppe Perna, Carlo Baldi, Frances Thole, Frank Roma, Rocco DiNubile, and Ernest Orlandi helped Giannini with this *opera d'arte*. (Courtesy of Baldi family collection.)

Here is the studio of Vincenzo Bellino at 806 South Christian Street. Bellino arrived in the United States in 1890. His was considered the best photography studio in the entire city of Philadelphia, according to the local newspaper the *Public Ledger.* He also used flash photography at this early period. (Courtesy of Baldi family collection.)

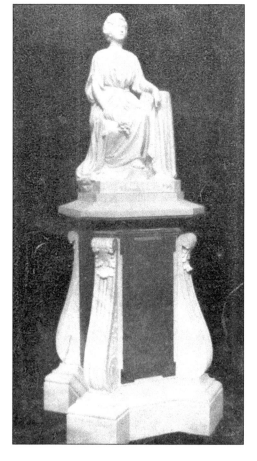

This sculpture was dedicated to Theresa Warner's daughter Caterina, who died in 1902. It can be seen in Holy Cross Cemetery. Holy Cross was the resting place for many of the Catholic Italians from Little Italy. It was located outside the city limits across the Cobbs Creek in Yeadon. It is ironic that one had to go so far to be buried when there was a cemetery at Sixth Street just south of Washington Avenue. But this was primarily for soldiers from the Civil War. (Courtesy of Baldi family collection.)

Theresa Trafficante Warner was a famous artist whose work is seen at the bottom of page 38. She lived at 914 South Seventh Street. She came to America in 1868 and worked as a midwife. (Courtesy of Baldi family collection.)

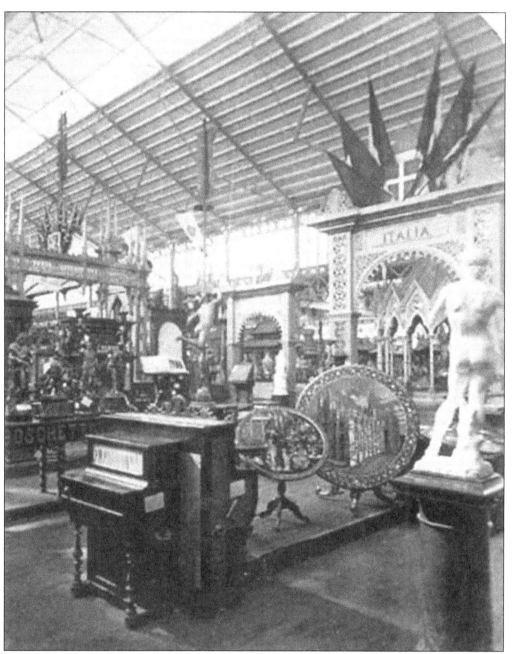

The centennial was celebrated in 1876 with a world's fair. Over 300 sculptures and 600 paintings were contributed by the newly unified Italy. There were paintings of the night of October 11, 1492, when Columbus saw the lights of the natives on the island of San Salvador in the Bahamas. The items were in the Italian Annex. Most of the recorded images are stereoscopes. A statue of Christopher Columbus was erected for the Centennial Exhibition in 1876 in Fairmont Park at Fountain and Belmont Avenues. At the invocation by Father Antonio Isoleri from St. Mary Magdallen, he told of his hopes that the Vatican would declare Columbus as St. Christopher by the 400th anniversary in 1892. The statue was moved to Marconi Plaza in the 1970s by Mayor Frank Rizzo, the first Philadelphia mayor of Italian descent. (Author's collection.)

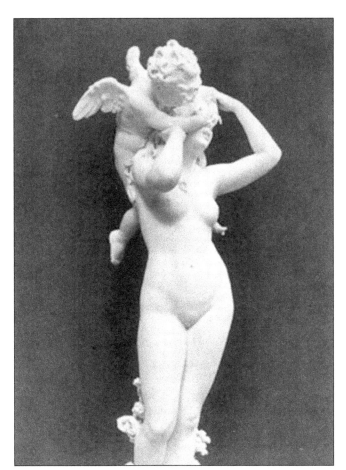

Many of the sculptures for the centennial were focused on love and people. The sculptures were done by artisans in all the major cities in Italy, including Milan, Florence, Rome, and Naples. (Both, author's collection.)

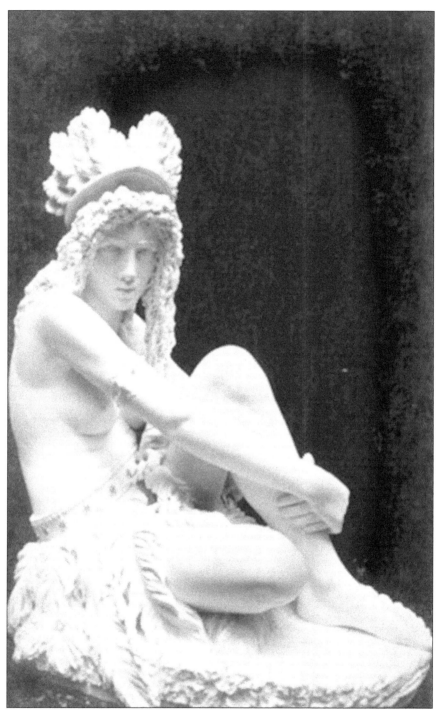

Africane was produced by the Florentine sculptor Emanuele Caroni, a professor at l'Academia d'Arte di Firenze, which was founded by professional artists from the prestigious Accademia di Belle Arti di Firenze. He was also a commissioner to the exhibition. One can see in the lineaments of her face the betrayed woman's mind. Also note the beautiful feather headdress. (Author's collection.)

Six

LITTLE ITALY AND ITS 9TH STREET MARKET

The Italians of Little Italy first did most of their shopping on Eighth Street from Fitzwater Street to Carpenter Street. The Genoese like Francesca Cuneo understood that Italians would never assimilate their food habits, so they began to sell macaroni, olive oil, Italian cheeses, spices, and salami and other preserved meats. One local immigrant recalls that the market moved about the time the trolley route on Ninth Street changed to run to Center City and on Eighth Street to South Philadelphia. Pushcart trade began at Ninth and Christian Streets. These merchants were Sicilians. The pushcarts were loaded with fruits and vegetables from the Dock Street Market. The pushcart vendors were kept out of the Genoese-owned stores on Eighth Street, so they tried Christian Street between Eighth and Ninth Streets in front of the Church of Our Lady of Good Council. Eventually they moved towards Ninth Street, which was then still a quiet residential street. By 1905, the line of pushcarts had finally turned off Christian Street onto Ninth Street and began forming up Ninth Street to Carpenter Street. Housewives were happy not to have to go to Dock Street, and it worked well.

What was life like in Little Italy? The *Bolletino dell'emigrazione* indicates the Italian quarter is comprised of approximately a 1.5-kilometer square. It is divided like a chessboard with seven streets from south to north and six from east to west. It is therefore comprised of 42 blocks of houses. Each block is subdivided with alleys to render access to the houses at the center of the various courts.

Philadelphia is known for its uniform row houses designed for single families. The houses of the laborers are commonly a ground floor with two rooms beyond the foyer and a second floor with two or three rooms. There is rarely a third floor. Every block includes approximately 140 houses; the Italian quarter can count about 5,880 houses. Italian housewives washed their clothes at the fire hydrant in warmer weather. Light was provided in the early row homes by candles or oil lamps. The parlor would have one good chair and a table. However, some were trapped in the back allies and courtyards in small trinity homes, which although they were three stories high had only one room per floor. According to the Italian government, there were about 5,880 homes inhabited by Italians in this small area around the beginning of the 20th century. The City of Philadelphia records that there were about 180 businesses in this area. At the turn of the 20th century, with about 100,000 Italians throughout all of Philadelphia, about 70,000 were crammed into Little Italy.

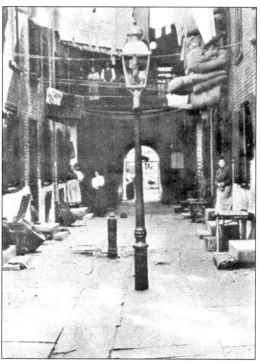

Donnelly Court is located off Montrose Street between Eighth and Ninth Streets. Italians who voted during the election of 1853 were living here. They are accused of ballot stuffing in the *Public Ledger* of November 1853. Counting both sides, the courtyards often had over 65 people living there, all sharing one privy. (Author's collection.)

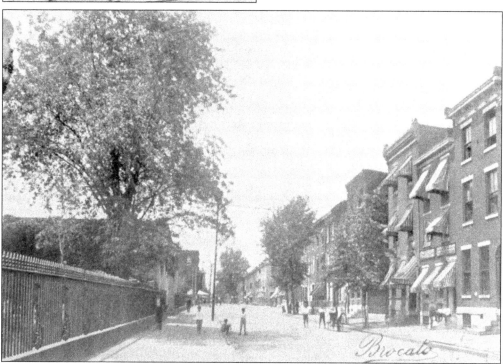

Federal Street is seen in a view from Ninth Street looking west to Tenth Street. The Lafayette Cemetery is still on the left. The tombstones can be seen through the iron gate. This was the natural boundary of Little Italy during the early 1900s. Today, this is the scene across from Pat's and Gino's Steaks. (Courtesy of Baldi family collection.)

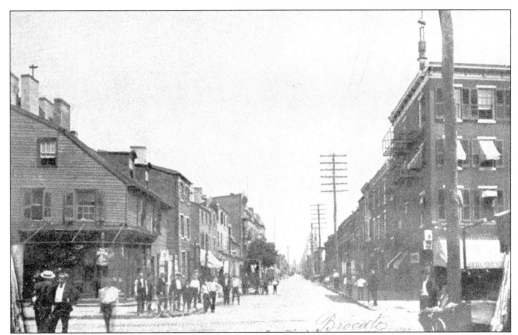

Here at Carpenter Street, seen from Eighth Street, a bicycle is visible on the left. Note the symbol for Bell Telephone on the right. According to many, the telephone was invented by the Italian Antonio Meucci in 1871. He had obtained a provisional patent but was financially unable to defend his claim, so in 1876, the patent went to Alexander Graham Bell. (Courtesy of Baldi family collection.)

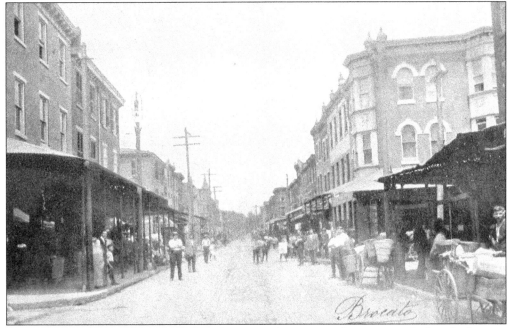

On Ninth Street, seen from Carpenter Street, vendors are on the streets with their baskets on pushcarts. Even today, many of the stands are still on metal wheels. The baskets have been replaced by cardboard or wooden crates. (Courtesy of Baldi family collection.)

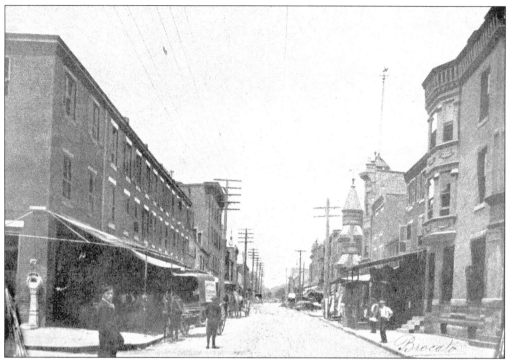

Seventh Street, seen from Carpenter Street, runs north to south. Carpenter Street was probably one of the earliest streets in Little Italy to have large concentrations of Italians. In 1873, Italian children were being held in bondage on this street by *padroni* (masters). They would be sent out to wander the streets, scraping out horrible music. Many of the padroni lived at Seventh and Carpenter Streets. (Courtesy of Baldi family collection.)

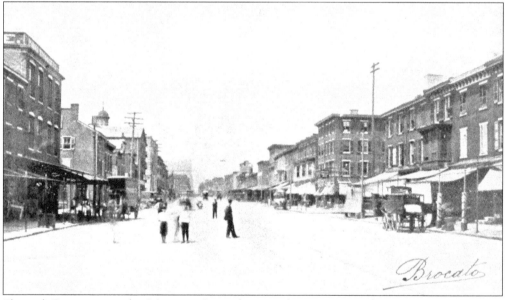

Eleventh Street, pictured at Montrose Street, became the westernmost limit of Little Italy by the beginning of the 20th century. Eleventh Street formed a natural boundary, as it dead-ended at the Moyamensing Prison to the south. (Courtesy of Baldi family collection.)

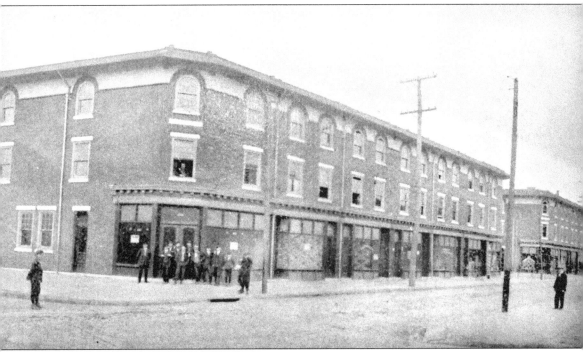

Pictured is the northeast corner of Eighth Street and Washington Avenue. This property was owned by Giorlano Tumolillo, whose bank was just down the Eighth Street from here. Tumolillo was also involved with the Italian Lines, helping immigrants to arrive at the wharves eight blocks away. He owned 45 houses, identifiable by their unique arched windows on the third floor. He was president of the League of Bankers and also donated towards earthquake relief in Calabria and Messina, Sicily, in 1908. (Courtesy of Baldi family collection.)

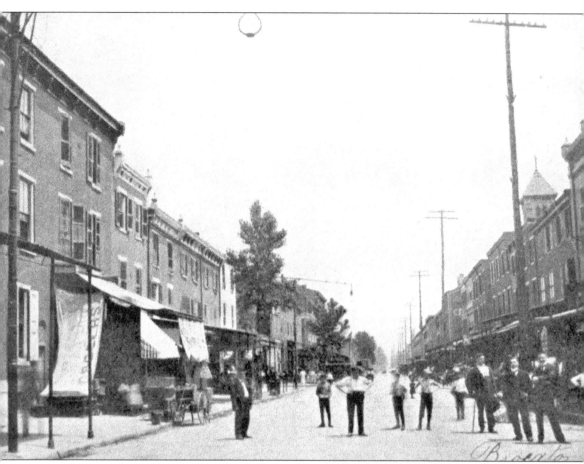

Christian Street is seen from Ninth Street. The cupola of Our Lady of Good Counsel Church is on the right. Notice that the vendors traditionally associated with Ninth Street are also here on Christian Street. Look at the Edison-style lightbulbs in the streetlights. Christopher Morley writes in his book that there were pastry shops here and there were theaters on the next block past the church between Seventh and Eighth Streets. Fish are also visible on Christian Street, many of them in kegs. Cheeses, vegetables, and herbs can also be seen. (Courtesy of Baldi family collection.)

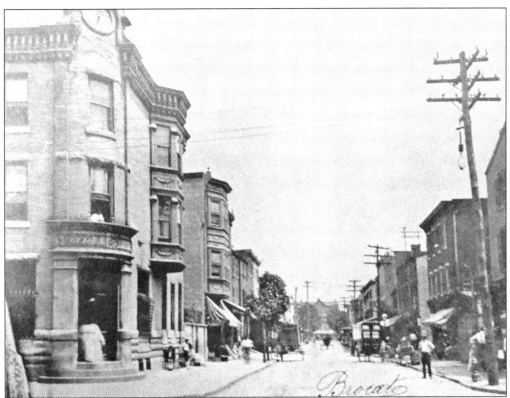

Here are Seventh and Fitzwater Streets in a view looking eastward. On the left is the Bozelli bank on the northeast corner. Lorenzo Bozelli, from Roseto Valfortore, Foggia, was in business with Antonio Lotti and had to pay $7.95 in income taxes to the state treasurer as early as 1895. The clock tower shows the date when the building was constructed, 1893. In the distance about two blocks down is where Passyunk Avenue traverses Little Italy. (Both, courtesy of Baldi family collection.)

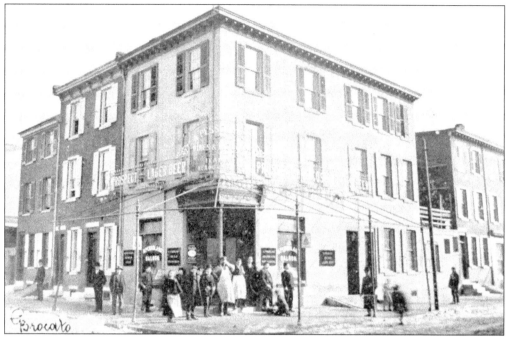

Nicola Pessolano was from Atena Lucana. He ran a business at Sixth and Fitzwater Streets. Across from this corner, on the northeast corner of Sixth and Fitzwater Streets, the second church for Italian immigrants opened in 1895. Our Lady of Pompeii Church was run by the Cardarelli brothers. It remained opened until 1897, when the diocese shut it down. The diocese then opened Our Lady of Good Council on Christian Street. (Courtesy of Baldi family collection.)

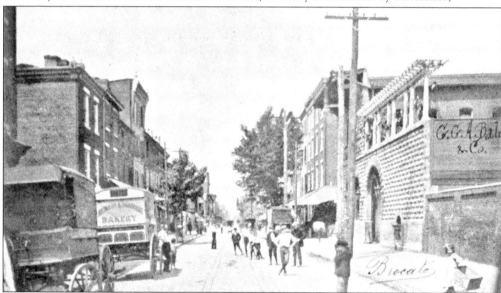

Eighth Street is pictured in a view looking towards Washington Avenue. Trolley tracks run along Eighth Street. This photograph was taken at Kimball Street. On the right is the Baldi funeral home. Notice the fountain. The trolley used to go north. About the turn of the 20th century, the trolley changed direction to come south. It is about this time that the market moved from Eighth Street to Ninth Street. (Courtesy of Baldi family collection.)

50

These houses are at the northeast corner of Eighth Street and Washington Avenue. The property was owned by Tumolillo. His bank was just down the street from here on Eighth Street. (Courtesy of Baldi family collection.)

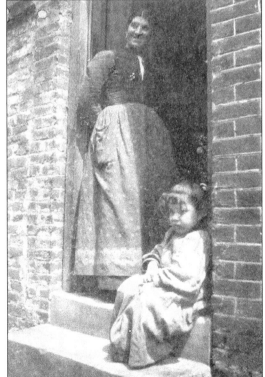

Here is an entrance to a home on the 700 block of Clymer Street. This is a typical stoop in Philadelphia, with only two steps. An unidentified woman is pictured with her young daughter. (Author's collection.)

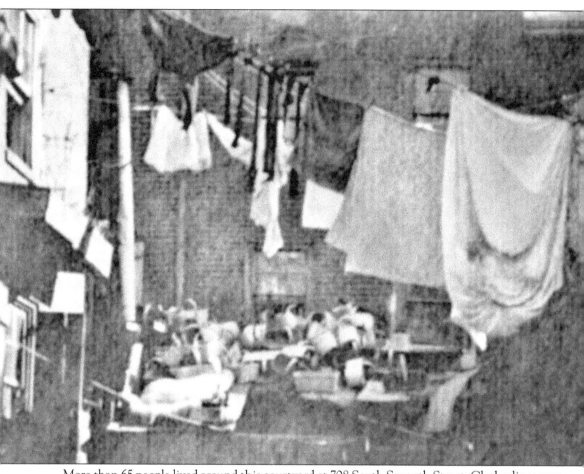

More than 65 people lived around this courtyard at 708 South Seventh Street. Clotheslines were strung across the central court. People shared a common privy. Many of these courts had goats running through them and rag pickers. There was also an Italian marionette theater nearby. The Sicilians of Palermo were famous for these marionettes. (Author's collection.)

The bedroom of a tenant in a courtyard home is depicted here. Notice the boards above the bed to keep water off. The bed is made despite the deplorable conditions of the room. (Author's collection.)

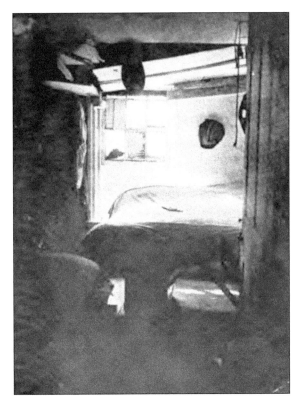

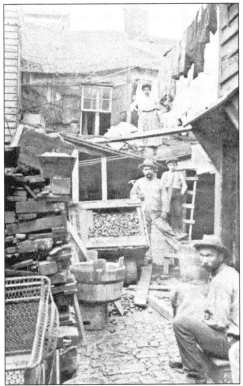

This is the rear of the home at 616 Pemberton Street. Note the entrance to another home on the right side. Early taxes were paid on the frontage of property. It was typical to have properties as deep as 120 feet. Often, a second house would be put in the back with a rear or courtyard entrance. (Courtesy of Baldi family collection.)

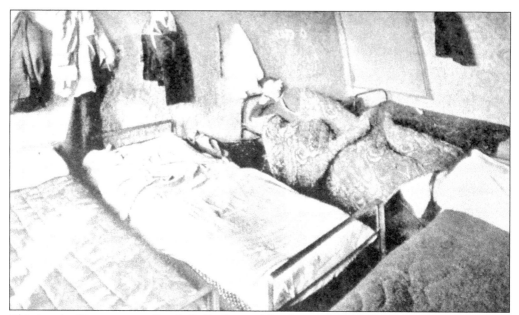

This is a dwelling room on South Delhi Street. Most homes averaged five people to room. One can see the many beds in the room and how tight the actual living conditions were for the average immigrants in their first years in this country. The "bedroom" had both day and night sleepers. (Author's collection.)

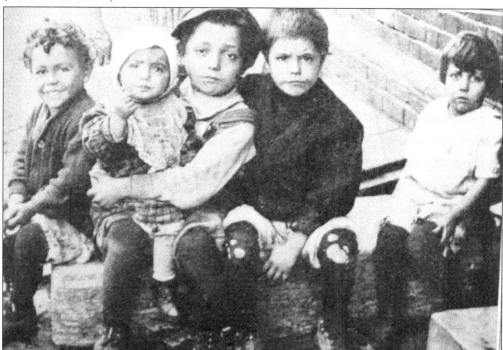

Here is a group of Italian children in Little Italy. Despite the deplorable living conditions, the children appear to have remained happy as can be seen in this picture. In Italy, most Italians are very resilient. The author's grandfather said that when they had little to eat they would joke and say, "We will have water with a fork for dinner." In other words, life is what a person makes of it.

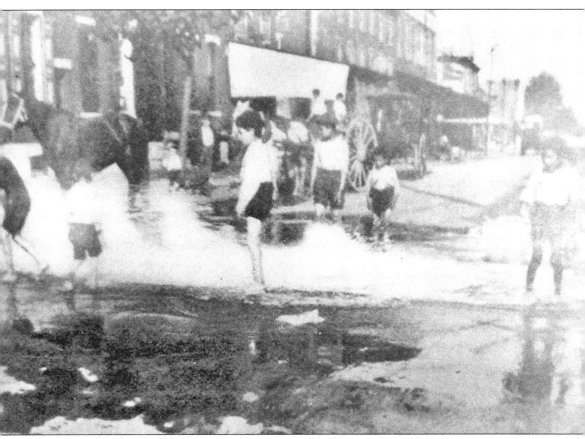

Here, a group of children takes an impromptu bath with a fire hydrant in 1902. In the summer, poor children often sought the relief of fire hydrants. It was customary for the biggest children to position themselves on the hydrant so all the others could be sprayed. (Author's collection.)

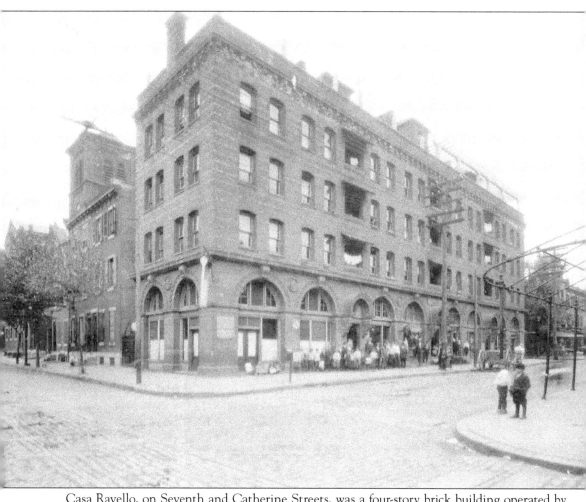

Casa Ravello, on Seventh and Catherine Streets, was a four-story brick building operated by the Octavia Hill Housing Association. Its goal was to provide decent housing to Philadelphia's poor. The apartments consisted of two and four rooms. Doctors and nurses provided childcare. (Author's collection.)

Seven

THE SOCIETIES

There were over 85 mutual aid societies in Philadelphia. The purpose of these societies was to provide assistance to members who lost their jobs or to family members of those who died. They also provided assistance to the victims of earthquakes, floods, or other disasters in Italy. The Societa Unione e Fratellanza Italiana, founded in 1867, was one of the oldest. Most of the various regions of Italy were represented: Avellino, Marmora, Monterodunese, Calabritto, Gessopaleno Abruzzi (Molise and Abruzzo), Calabrito, Spezano Albane, and Venafro. Religious groups were dedicated to the patron saints of their areas: San Rocco, Our Lady of Mount Carmel, St. Lucy, Our Lady of the Snow, St. Nicholas, Cosmo and Damian, Salvatore, or St. Gerard Maillo.

Little Italy Philadelphia had many mutual aid societies; 36 were for men and 5 for women. Other societies were of a different character—religious, musical, or Masonic. The Italian Masons had 5,000 associates and a capital of 300,000 lira. Several of them were formed by individuals from the same region, and also from citizens of a common town. And they all have a national and patriotic character. They were chartered by the state or city for all the legal ends. Nearly every society has its festive anniversary—consisting of a picnic, or a dance, or a banquet. Such festivities are always crowded and open to the public, which satisfied the income tax. The Italian consul is always invited.

Two societies possess also an elegant center. One observer admired the order and honor that reigned during those society meetings. They served as a school for the honest, rank-and-file laborers of which the society was composed. The societies succeeded to become the spirit of the colony and to represent it, as today they serve to make one collective demonstration of Italianism or sympathy for the adopted country of the United States. The societies served for many solemn commemorations of Santissima Maria, King Umberto, Master Verdi, and even Duca of the Abruzzi in October 1896.

As part of mutual aid societies, the members not only helped the locals but also raised large sums for serious calamities that happened in Italy and even to support Italians affected by the Great San Francisco Earthquake.

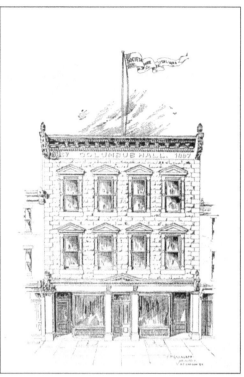

This is an image of Columbus Hall at 746 South Eighth Street. Founded in 1867, it was originally a fire hall until the Italians bought it. It served as the meeting place for Italians for the Societa D'Unione e Fratellanza. (Author's collection.)

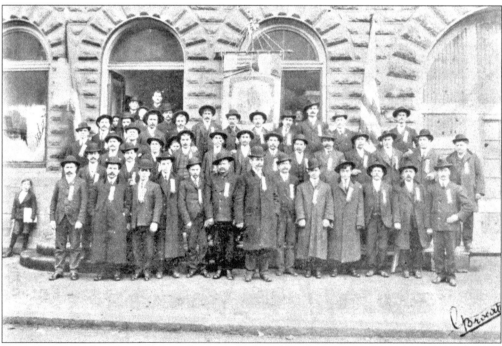

Santa Barbara Italian Society's president was Carlo Baldi. The group's purpose was philanthropic. It donated to victims of earthquakes in Calabria and San Francisco and to those of the eruption of Mount Vesuvius. With only 73 members, it was able to collect over $1,000 in three years at a time when most people were earning only $1.50 a day. (Courtesy of Baldi family collection.)

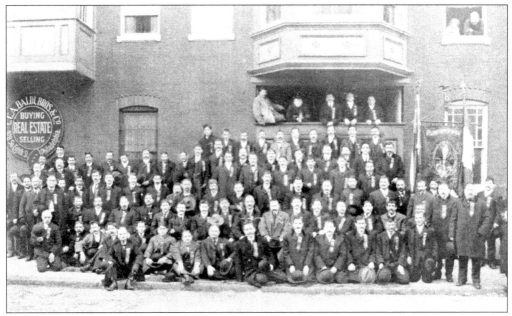

Dues for Mutuo Soccorso di San Biagio were paid according to age. To join, members had to pay $2 (between 18 and 25 years old), $3 (between 26 and 35), $4 (between 36 and 40), and $5 (between 41 and 45). Each member paid $1.50 every three months and a funeral tax of 25¢. The society's purpose was to help the families of members. If a member died, his wife would receive $100. The group met every other Sunday. (Courtesy of Baldi family collection.)

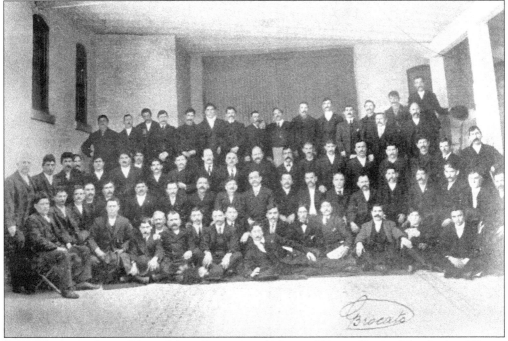

Pictured are members of Santa Maria Santissima di Acqua Cilento, Regina Margherita. Cilento is on the southern coast of Salerno. The group's headquarters were at 1024 Montrose Street. (Courtesy of Baldi family collection.)

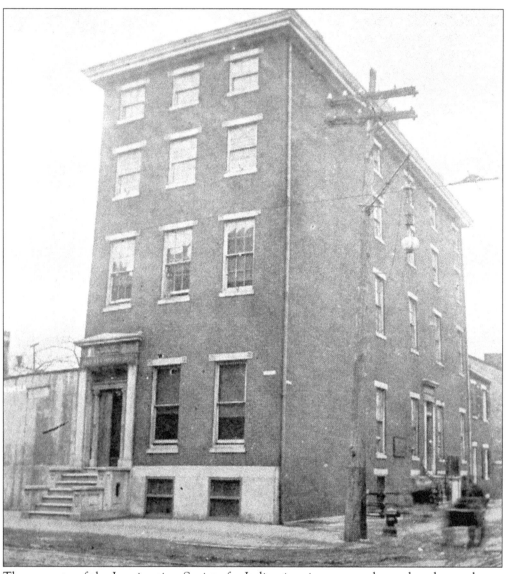

The property of the Immigration Society for Italian immigrants was located at the southwest corner of Tenth and Bainbridge Streets. The society was run by director Emmanuel Nardi along with Harry Gandolfo, Frank Travascio, and Dr. Michele DeVecchiis as associates. They also ran a nursery and a school for citizenship. (Author's collection.)

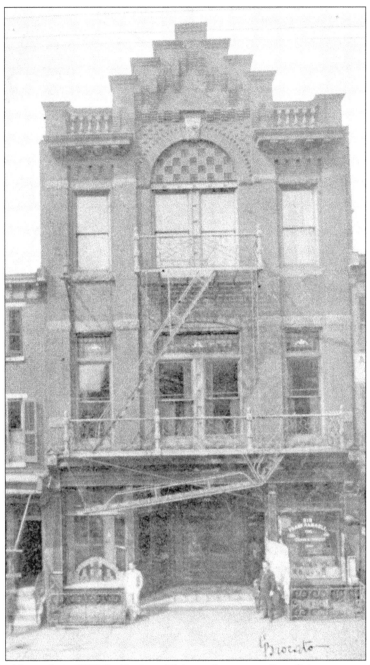

Established by 40 people in 1880, La Societa di Mutuo Soccorso e Beneficianza was at 918 Fitzwater Street. Initially, the president was D.A. Pignatelli, T.P. Scalella was secretary, Francesco diMaio was vice president, Giuseppe Palermo was vice secretary, Gennario Cattafesta was *censore*, and Francesco Campiglio was treasurer. The scope of this society was mutual aid for the poor and survivors. The administration in 1905 included Vincenzo Brunetti (president), Luigi Storlazzi (vice president), Vincenzo Colaiezzi (secretary), Giovanni Gargano (secretary of finance), Michel Dragonelli (vice secretary), and Mario Rossi (vice secretary of finance). (Courtesy of Baldi family collection.)

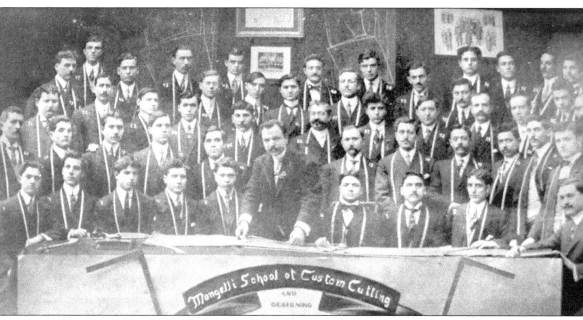

Giuseppe Mongelli founded the Academy of Custom Cutting in 1896. In 1898, he wrote a book on the art of cutting in 1898. In 1905, Mongelli won an award for his cutaway frock against 300 competitors at the Continental Hotel. (Courtesy of Baldi family collection.)

Eight

BANKING

Despite that fact that their wages were the lowest out of 23 immigrant groups, it is amazing how much was saved by Italian immigrants. Italians earned about $1.50 to $2 a day at the beginning of the 20th century. However, they only needed 50¢ to live. They sent the rest home to their families in Italy to invest in land, to pay old debts, or to allow them some day to return to enjoy the fruits of their work. It was the opinion of the early Italians that German and Irish immigrants consumed everything they earned. The Americans wanted money earned in this country to be consumed here. It was believed by the editors of the newspaper *L'Opinione* that "for this reason there were restrictions against the Italians." It was also believed that if the Italian established himself here, he would consume all his earnings here.

It is reported by *L'Opinione* that Italians saved almost 70 percent of their earnings. As early as 1893, there were 25 banks in Little Italy. It is no wonder that there were so many banks in the neighborhood, as Italians invented banking. The word derives from *banco*, the name for the table where the early transactions took place in Florence and Venice. Ironically, the leaders of the bank in Florence were members of the Alberti family, who moved to Venice when the Medicis came to power. The Albertis came to America in 1624, and their descendants are recorded as settling in Philadelphia as early as 1759. Many Italian banks prospered and others came on the scene until the stock market crash in 1929, when almost all of these banks fell. Bankers wrote letters, transmitted money to Italy, and acted as lawyers, realtors, employment agents, and travel agents selling tickets back to Italy. Additionally, bankers were involved with regular passenger service. They helped immigrants get back to Italy, as most Italians did not come here with the intent of staying. Forty percent returned to Italy. Americans referred to them as "birds of passage." The rates bankers charged were high, but, except for one publicized incident, bankers did not abscond with the money. They took care of any sum of money, no matter how small.

Although called *bancas* or banks, many were actually building associations, such as the Prima Associazione Italo-Americana. Its goal was help everyone to buy a house or to help people build one. It lent money, which borrowers paid back monthly. The administration included Domenico Biello, Franco Travascio, Victor Fermani, Vincenzo d'Ambrosio, Emanuale Nardi, B. Cavagnaro, T. Del Vecchio, F. Bilotta, Giuseppe Tambone, Ramondo Curatolo, Tommasso Paolino, Francesco Palumbo, Nicola D'Alonzo, Giuseppe Valinote, Giovanni Queroli, and Vittorio Michelotti. It was located in Columbus Hall at 746 South Eighth Street.

Banca di Calabria was at Seventh and Christina Streets. Frank Bilotta was the president. He ran the bank with his son-in-law Giovanni Ferraro, from Lungro Albanese, Cosenza. The bank was located on the ground floor of this beautiful palazzo, considered by many to be the most beautiful bank on Seventh Street. Ferraro was so wealthy that he owned 16 houses by the early 1900s. He also ran a building and contracting company. Bilotta was also involved with his in-laws, the Donatos, who ran the Banca Mediterraneo at 819 South Eighth Street and a building and loan association. (Courtesy of Baldi family collection.)

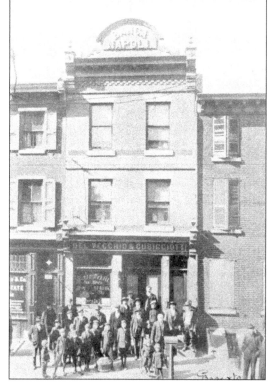

Pictured is the Banca Napoli, owned by Marco Del Vecchio and Alfonso Cubicciotti and opened in 1901. Del Vecchio was from Venafro, Abruzzi (today Molise), while Cubicciotti was from Campagna. These two were viewed as honest and were members of various mutual aid societies. Del Vecchio was a president of the Societa Unione e Fratellanza, founded in 1867. (Author's collection.)

Brothers Biagio (pictured), Giovanni, and Giuseppe Bersani ran La Banca Provinciale Romana at 810 South Seventh Street. They were born in Sonnino, Roma. Their father, Allesandro, did everything to ensure that his sons were educated well. The bank opened in 1905, and soon all their Roman *paesani* were running there. (Courtesy of Baldi family collection.)

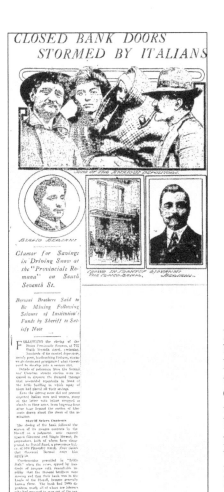

In 1908, when the Bersani brothers closed the bank's doors, Italians stormed the doors of La Banca Provinciale Romana at 772 South Seventh Street in the driving snow. Policemen from the Second and Christian Street Stations were required to disperse the frenzied throngs that assembled in front of the building. Three thousand of the poorest people had placed all their savings in the bank. Some of the women came with their babies wrapped in shawls in their arms. Apparently, the bank was closed because Daniel Sassi, who ran a bank at 816 Fitzwater Street, said he was owed $27,777.50. (Author's collection.)

Michele Martino was from Abruzzi (Molise). He was the proprietor of a bank at the corner of Montrose and Eighth Streets. (Courtesy of Baldi family collection.)

Luigi Volpe was born in Stella di Cilento, Salerno, in 1868. He first went to New York in 1880 and opened a brewery. In 1889, he opened a bank office in Philadelphia along with his brother under the name L. Volpe and Co. His bank accumulated $78,400, which he returned to his clientele when he returned to Italy. In 1902, Volpe returned to Philadelphia, where he opened a bank office at 908 South Ninth Street. He also had a gold and jewelry store. The bank then moved to the southeast corner of Tenth and Carpenter Streets. (Courtesy of Baldi family collection.)

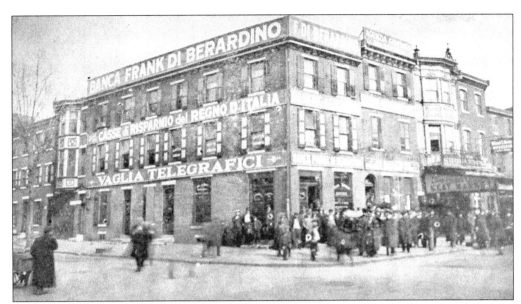

One of the longest-lasting banks was that of Frank DiBerardino, which continued well into the 20th century. DiBerardino specialized in assisting emigrants from the Abruzzi region. Here is his bank at 821 Christian Street. As can be seen, this was not only a bank but also a telegraph and maritime agency. DiBerardino's bank also had branches in West Philadelphia and Pittsburgh. He advertised as a steamship ticket agency. (Courtesy of Baldi family collection.)

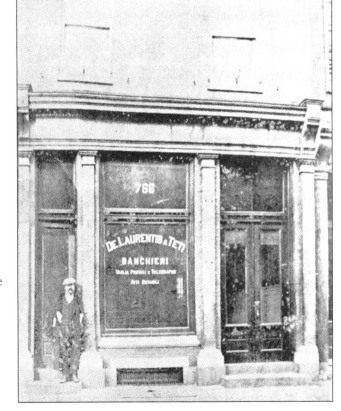

Here is the DeLaurentis & Teti Bank at 776 South Ninth Street. DeLaurentis came to America in 1889 and Teti in 1890. They opened the bank together in 1904 after Teti made the proposal to DeLaurentis. Their business was booming early on. Both partners were from Torricella Peligna, Chieta. Their bank had a different location in 1905, which can be seen on page 72. (Courtesy of Baldi family collection.)

Here is the bank of Frank Cerceo and Thomas Cialella at 700 Christian Street. This bank also served as a ticket agency for boats and provided postal and notary services as well. A Mr. Longo was previously in business with Cerceo as early as 1898. Prior to this business, Phillip Rogo ran a bank at this corner. (Author's collection.)

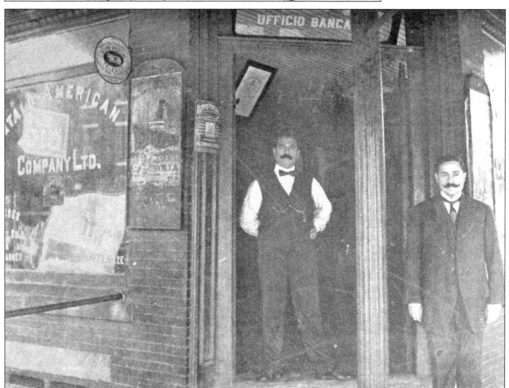

The Italo-American Company was located at the northwest corner of Ninth and Christian Streets. The bank started in 1905 and was managed with equity by Joseph Ciavarelli and Giuseppe Serafini. They also ran a navigation agency, post office, and notary. (Author's collection.)

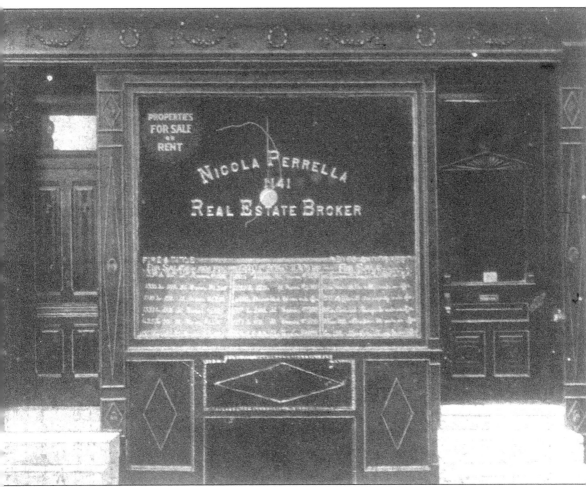

The real estate brokerage of Nicola Perrella was located at 1141 Federal Street. (Courtesy of Baldi family collection.)

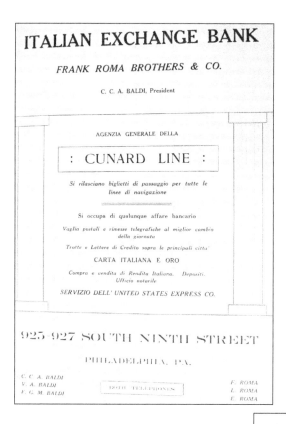

ITALIAN EXCHANGE BANK

FRANK ROMA BROTHERS & CO.

C. C. A. BALDI, President

AGENZIA GENERALE DELLA

: CUNARD LINE :

Si rilasciano biglietti di passaggio per tutte le
linee di navigazione

Si occupa di qualunque affare bancario

Vaglia postali e rimesse telegrafiche al miglior cambio
della giornata

Tratte e Lettere di Credito sopra le principali citta'

CARTA ITALIANA E ORO

Compra e vendita di Rendita Italiana. Depositi.
Ufficio notarile

SERVIZIO DELL' UNITED STATES EXPRESS CO.

925-927 SOUTH NINTH STREET

PHILADELPHIA, PA.

C. C. A. BALDI
V. A. BALDI
F. G. M. BALDI

BOTH TELEPHONES

F. ROMA
L. ROMA
E. ROMA

The Italian Exchange Bank was a joint venture of two families from the Salerno region, the Baldi family from Castelnuovo Cilento and the Roma brothers from Colliano. They had two offices on South Eighth Street. As exchangers, they bought and sold foreign currency and represented the Bank of Naples. (Courtesy of Baldi family collection.)

Banca d'Italia was at Seventh and Pemberton Streets. This bank was run by the DiGenova family from Montella, Avellino. Gennaro DiGenova immigrated in 1876. He married Benedetta Silvestro di Tobia from Monteroduni. Gennaro started with a fruit business in 1883. After that, he sold beer and liquor at 810 South Street. In 1895, he founded the bank seen at right. The bank also sold train tickets as well as boat tickets to Europe and South America, exchanged money, and performed notary services. It worked with the Lloyd agency to export anything to Italy. (Courtesy of Baldi family collection.)

This is the business of Ferdinado Bartilucci at 720 South Seventh Street. Born in Accettura, Consenza, he emigrated in 1872 from Calabria. He was instrumental in obtaining contracts for water and gas lines and was a large supplier of material for tanneries and a new general contracting industry. Bartilucci always used Italian workers. His fortune was calculated at $100,000 in 1905. (Both, courtesy of Baldi family collection.)

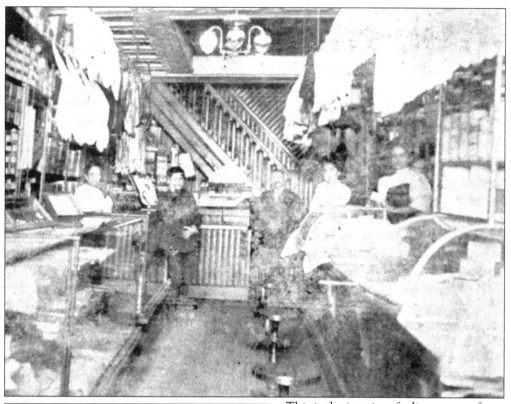

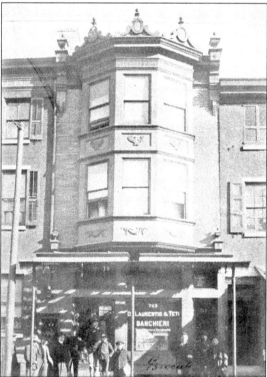

This is the interior of a linen store of Achille D'Orazio at 1020–1022 South Ninth Street. D'Orazio immigrated to Philadelphia in 1886 and worked for 10 years in a brewery. With savings from his work, he opened this store, the first of its kind in Philadelphia. (Courtesy of Baldi family collection.)

DeLaurentis & Teti Bank was located at 743 South Ninth Street. Both DeLaurentis and Teti were from Torricella Peligna, Chieti. They immigrated in 1889. The bank opened in 1904. DeLaurentis was also a member of the Societa Unione Abruzzesse. (Courtesy of Baldi family collection.)

Banco di Napoli, at 750 South Seventh Street, was run by Domenico Biello. Biello was born in Monteroduni. He also ran a watch repair and jewelry story (pictured). He was at this location beginning in 1887. Biello had many responsibilities, including being a member of the Red Cross, vice president of the Italian Building Association, and a member of the administrative council of *L'Opinione*. Apparently, he was also connected with Cesare Conti, who also ran the Banco di Napoli. (Courtesy of Baldi family collection.)

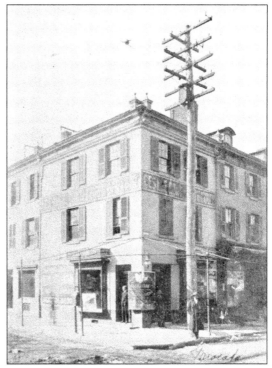

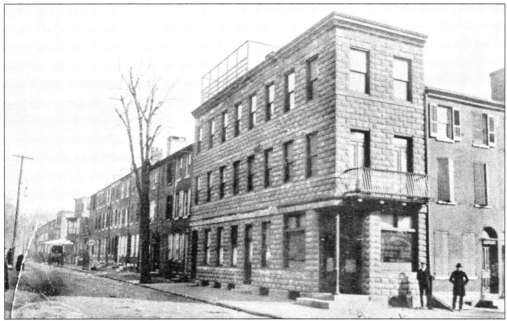

The Bank of P.L. Alessandroni e Figlio was at 921 Christian Street. This was a superb location at the center of Little Italy, and the building was constructed of artificial stone in 1904. Peter Alessandroni's young son Giuseppe decided to grasp the opportunity and open a bank on the first floor. They were from Marianopoli province of Caltanissetta, Sicily. Caltanissetta is in the interior of Sicily and is where the well-known liqueur Averna is made. (Courtesy of Baldi family collection.)

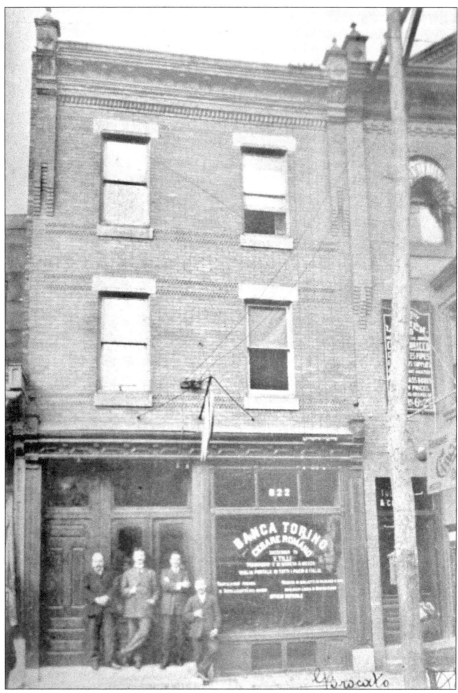

Cesare Romano owned the Banca Torino at 822 South Eighth Street. Though the bank was named Banca Torino, Romano was born in Paesi, Chieti. The Roma brothers were from Naples and ran a Banco di Napoli branch office. And the DiGenova family ran the Banca d'Italia, even though they were from Naples. Romano was also the proprietor of the Pottstown trap quarry and crusher. He furnished laborers for the railroad grading and reservoir. (Courtesy of Baldi family collection.)

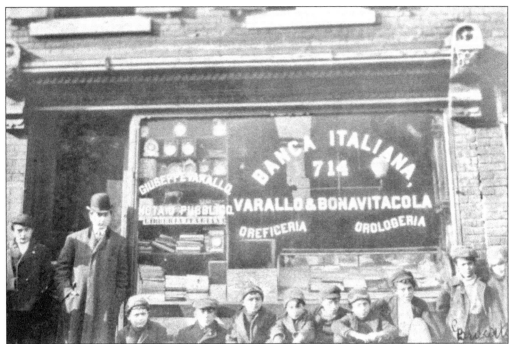

Banca Italiana was owned by Alessandoro Bonavitacola and Guiseppe Varallo. The sign in the window notes they also dealt in gold jewelry and watch repair. The bank was at 714 South Seventh Street. Varallo (pictured at right) came to America in 1887. He was a macaroni and bread maker until 1890. Bonavitacola was previously in Egypt as a soldier. (Both, courtesy of Baldi family collection.)

Alessandoro Bonavitacolo ran the bank along with Guiseppe Varallo. They both came from the hill town of Montella, Avellino. Immigrants from this town continue to come to Philadelphia. Guiseppe's descendants run the pastry shop Varallo on Tenth Street today. The Bonavitacolos run the famous Little Beth children's clothing boutique. (Courtesy of Baldi family collection.)

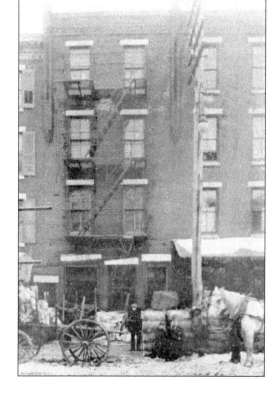

Pasquale Bova, of Marsico Vetere, Basilicata, sold wool, iron, and rubber from this establishment at 820 Carpenter Street. He was originally at 815 Carpenter Street, but business went so well that he bought this larger property. (Courtesy of Baldi family collection.)

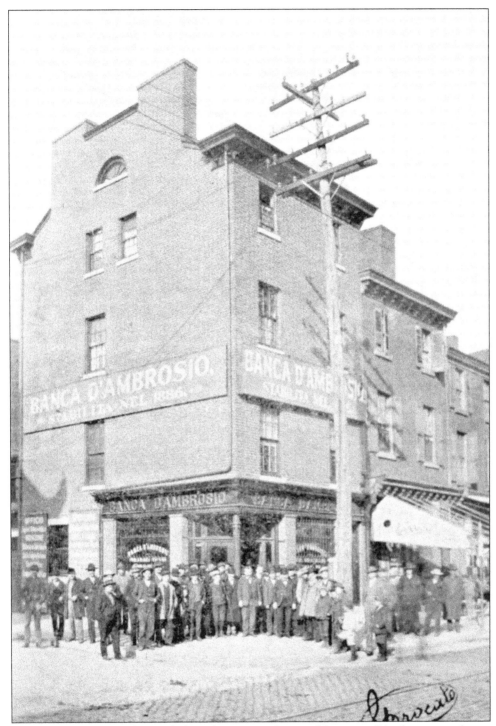

Banca D'Ambrosio stood at Eighth and Fitzwater Streets. Vincenzo d'Ambrosio was born in Torricella Peligna, Chieti. In 1886, he realized the Italians needed a bank, so he opened the first Italian bank in Philadelphia. He was also a real estate broker and even had an agency in Florida. (Courtesy of Baldi family collection.)

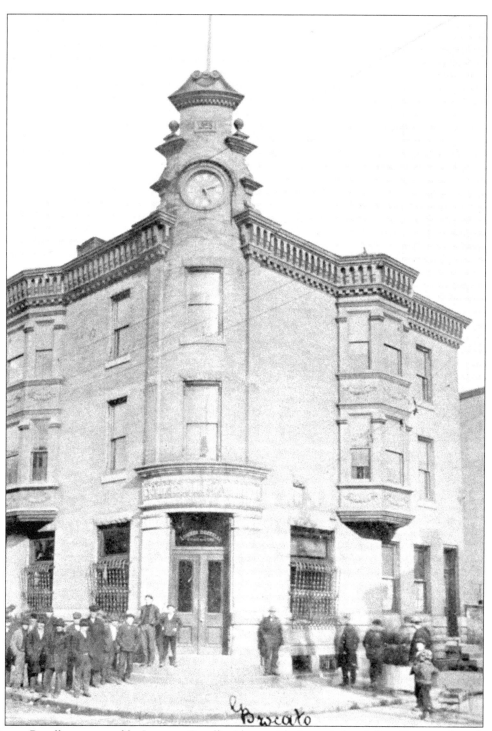

Banca Bozelli was owned by Lorenzo Bozelli. Along with Antonio Lotti, Bozelli opened a ticket office for passage to Italy and export in 1887. After Lotti retired in 1897, Bozelli worked directly with the Anchor Line of Glasgow. Bozelli was also the owner of the newspaper *Risorgimento*, published in Philadelphia in 1886. (Courtesy of Baldi family collection.)

Nine

FAMILIES AND REGIONS OF ORIGIN IN ITALY

Philadelphia in 1880 was still the second-largest city in the United States by population and the largest by land mass. Italian unification had only been completed in 1871, when Rome became the country's new capital. The Piedmontese who gained control in Southern Italy from the Spanish Bourbons imposed harsh taxes on the south up to a rate of 30 percent, notably in Sicily. Additionally, in 1864, as a result of the Civil War, "An Act to Encourage Immigration" was passed in America. Many western states and the railroads spent lots of money to advertise the benefits of the Promised Land. American contractors sought out padroni to obtain the cheapest possible labor. The padroni helped to arrange employment and bring many immigrants to this country. Some set up banks.

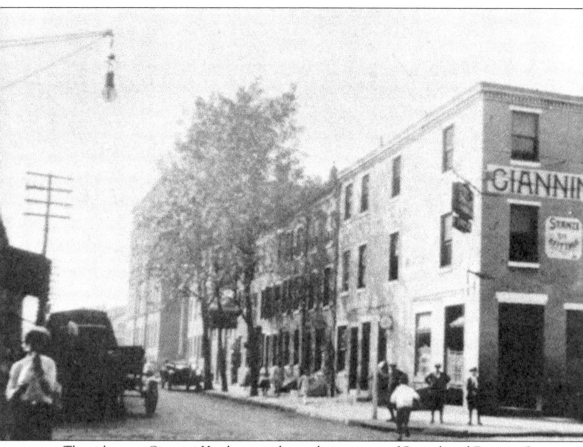

The eight-room Giannini Hotel was on the southwest corner of Seventh and Fitzwater Streets. Victor Giannini was from Ponte All'Ania, Lucca, in Northern Italy and lived at 70738 South Seventh Street. His bartender at the hotel saloon was Placido Parazza. Giannini lived in Chicago before coming to Philadelphia. (Courtesy of Baldi family collection.)

C.C.A. "Carmine" Baldi, the son of Vito and Rosa Galzerano, was born in Castelnuovo Cilento in 1862. He emigrated in 1877 and started as a fruit dealer. After two years, he moved to Atlantic City; but business got bad, and many Italians went back to the Italy. After his obligatory military service, Baldi emigrated again to Philadelphia to resume the fruit shop. In 1883, he worked as an interpreter with the Schuylkill Valley Railroad. Baldi also developed an extensive trade in coal, an undertaker business, and also a bank. (Courtesy of Baldi family collection.)

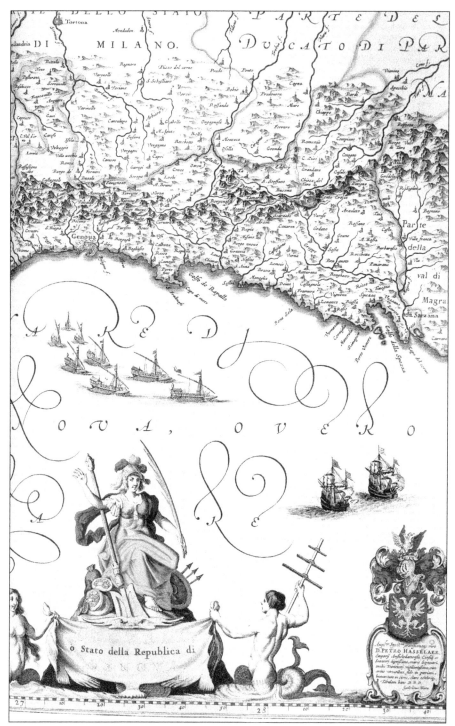

Genoa, on the Ligurian coast in Northern Italy, was one terminus for the Silk Road trade route from China, the other being Venice. Genoa became a city of merchants. Many of the earliest Philadelphia Italians were from Genoa, especially the area to south at Chiavari. The Genoese appeared in Philadelphia as early as 1847. (Author's collection.)

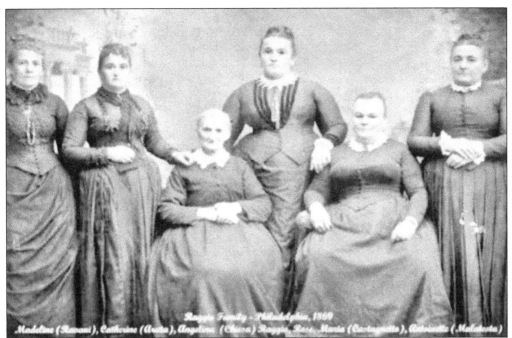

This is probably one of the earliest photographs of
Italian women in Philadelphia. Pictured in 1869
is the Raggio women from Cabanne, Genoa.
(Courtesy of Louis Arata.)

Francesco Cuneo was the nephew of
Agostino Lagomarsino. He was the owner of
the macaroni factory at Eighth and Christian
Streets. Cuneo's first wife died because her hair
got caught in the macaroni machine. (Courtesy
of Baldi family collection.)

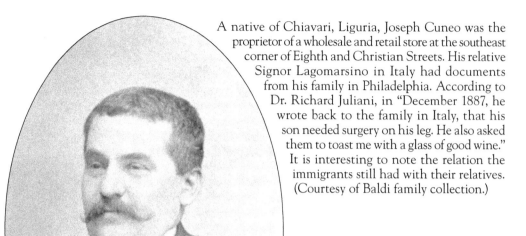

A native of Chiavari, Liguria, Joseph Cuneo was the proprietor of a wholesale and retail store at the southeast corner of Eighth and Christian Streets. His relative Signor Lagomarsino in Italy had documents from his family in Philadelphia. According to Dr. Richard Juliani, in "December 1887, he wrote back to the family in Italy, that his son needed surgery on his leg. He also asked them to toast me with a glass of good wine." It is interesting to note the relation the immigrants still had with their relatives. (Courtesy of Baldi family collection.)

Francesco Cuneo was a son of Joseph Cuneo. He took over his father's business when he passed. (Courtesy of Baldi family collection.)

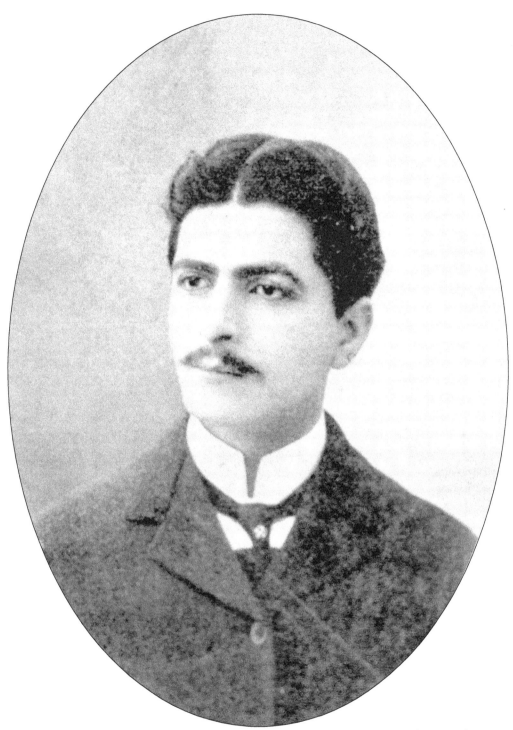

Pietro Paolo Lagomarsino had a shoemaking and shoeshine store at 55 North Seventh Street. Born in Genoa in 1872, he emigrated at the age of only 5. His always-thriving, well-stocked store was the only one in Philadelphia. (Courtesy of Baldi family collection.)

This is Giovanni Queroli. Born in Washington, DC, he went on to run a saloon at the corner of Eighth and Clymer Streets. A few doors away was Giovanni Gandolfo, the grandfather of local news anchorwoman Kathy Gandolfo. Queroli's family married Catherine Raggio, who had the macaroni factory at Seventh and Montrose Streets. (Courtesy of Baldi family collection.)

Emmanual Guano was born in 1852. He married Mary Raggio, the sister of his partner at the Guano Raggio Macaroni Factory, Antonio Raggio. The Raggio family was from Cabane, while Guanos were from Chiavari. The children pictured include Catherine, Elizabeth, Francis, Amelia, Irene, and May. Mary Guano's sister Luisa was the second baby baptized at Mary Magdalen in 1854. The grandmother of Mary Raggio was Caterina Cella, the sister of Antonio Cella, the founder of the Knife & Fork Restaurant in Atlantic City in 1907. (Courtesy of Baldi family collection.)

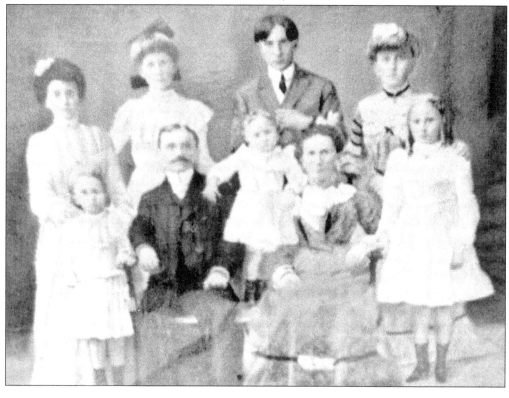

Amelia Guano, seen in her wedding photograph, married Walter Hodges, who lived across the street. His mother was the sister of Terence Toner, who listed in Philadelphia as early as 1843, when he sailed here. Amelia's mother was a member the Raggio family, which had been in the city since the 1850s and was one of the first families in Mary Magdalen parish. The Guanos' macaroni factory, at Seventh and Montrose Streets, provided the wealth to own a new home at 3414 North Nineteenth Street, where this picture was taken in the front bedroom on June 10, 1914. (Courtesy of Rosemary Guerilia.)

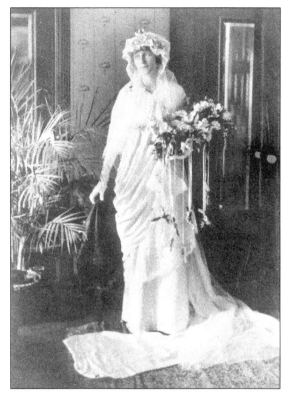

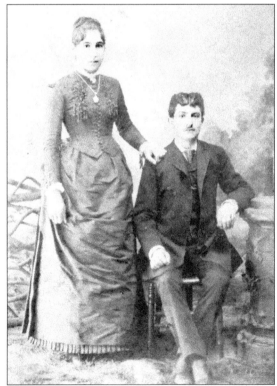

Amelia Filippini is pictured in 1883 with her husband, Frank Deritis. Amelia lived off Eighth and Pemberton Streets, across from the school that sat on what today is Cianfrani Park. She is remembered for bringing candy to the children at school. (Courtesy of Louis Arata.)

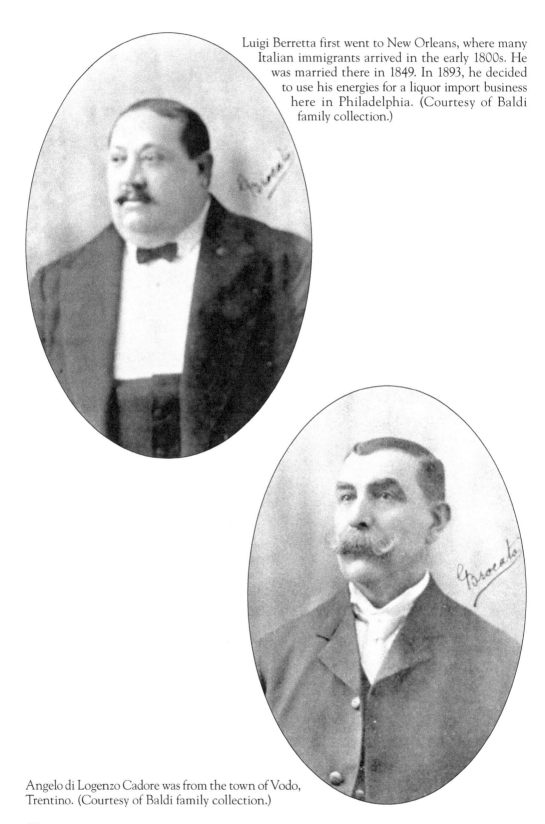

Luigi Berretta first went to New Orleans, where many Italian immigrants arrived in the early 1800s. He was married there in 1849. In 1893, he decided to use his energies for a liquor import business here in Philadelphia. (Courtesy of Baldi family collection.)

Angelo di Logenzo Cadore was from the town of Vodo, Trentino. (Courtesy of Baldi family collection.)

Michele Lastrico was condemned to death with Giuseppe Mazzini, Angelo Mangini, Antionio Bosto, Giovanni Batti Cassareto, and Ignazio Pittaluga on March 20, 1858, for their role in the Republic Conspiracy by the Court of Appeal in Genoa. Lastrico's efforts helped bring about the modern Italian state in place of the several separate states. He escaped to America in 1857. During the Civil War, he saw many battles as a volunteer in the Union army. Lastrico lived his last years at 13 Schell Court with enthusiasm and pride in his role in the fight for the liberty of Italy. (Courtesy of Baldi family collection.)

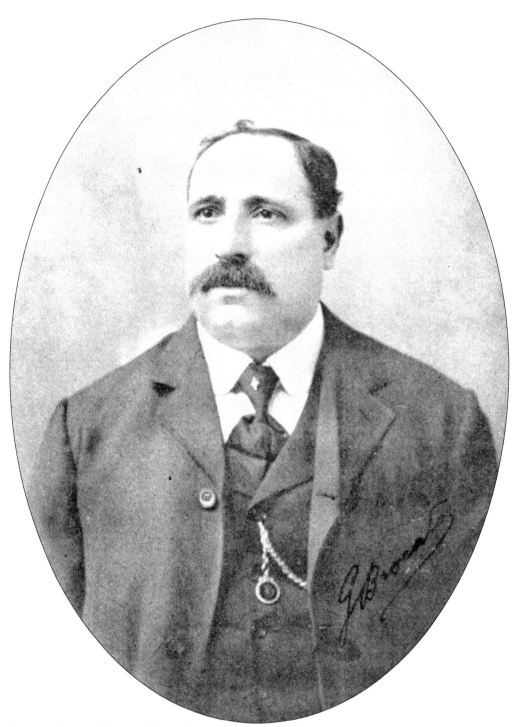

Pasquale Bova, of Marsico Vetere, Basilicata, went to France at the age of seven and was a *suono ambulanza*, a person who sounds the manual siren on an ambulance. He immigrated in 1874 to Philadelphia and started his business of selling and buying of rags. Many of the poorer Italians would pick rags and then sell them to Bova. (Courtesy of Baldi family collection.)

Francesco Travascio, from Castronuovo di Sant'Andrea, Basiclicata, ran a funeral parlor. He was very involved in supporting the victims of the eruptions of Vesuvius and Etna. (Courtesy of Baldi family collection.)

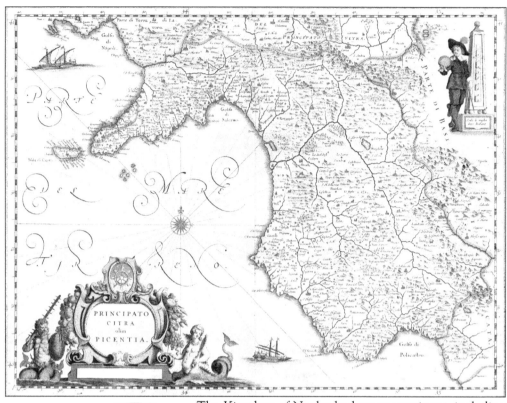

The Kingdom of Naples had many provinces, including Salerno, Avellino, and Benevento. This Vatican map shows the coastal area of Salerno, which is just below Naples. It is comprised of two famous coastal areas: Amalfi and Cilento. Many of the early Italians in Philadelphia, including the Baldi, DeVecchiis, and Roma families, came from the Cilento area and nearby hill towns. The area had been settled by Greeks and contains the ruins of the ancient town of Paestum, which has three Greek temples. (Author's collection.)

Severino Aleardo was from Acquaviva, Cilento, along the Cilentanto coast south of Amalfi. He emigrated in 1885 at only 15 years of age. Aleardo worked for seven years before he decided to open his own business. He realized there was a need for a milk dealer, so he opened his own store. Aleardo delivered using carts and horses that he bought and distributed 150 quarts of milk a day. (Courtesy of Baldi family collection.)

Alfonso Cubicotti was from Campagna. His hometown is next to Eboli, where Carlo Levi later wrote *Christo e fermato a Eboli* (*Christ Stopped in Eboli*), indicating the deep superstitions of Southern Italy. Cubicotti was in business with Marco Del Vecchio and ran a branch of the Bank of Naples on Eighth Street. (Courtesy of Baldi family collection.)

Antonnio DiNapoli was from the Avellino area. He went to Atlavilla Irpina, Avellino, and married Rosina Scioco. DiNapoli opened his own macaroni factory and made 9,000 lire in only two years. He then went on to open a second macaroni factory (pictured at the top of page 29). (Courtesy of Baldi family collection.)

Alfonso Baldi was the youngest of the Baldi brothers. A few years after his brothers established themselves in America, he left his studies in Italy to follow them here and actively assisted in their businesses. CCA Baldi Bros. & Co. was worth an estimated $350,000 in the early 1900s and was considered one of the most outstanding American firms in Philadelphia. (Courtesy of Baldi family collection.)

Fioravanti Baldi was in charge of the Baldi Coal Yard on Washington Avenue as the treasurer. The Baldis got their coal directly from the Pennsylvania coal mines. They had such good relations with the miners that in 1902 they were the only American company to receive a shipment of coal during a strike by the miners. (Courtesy of Baldi family collection.)

Pasquale Aceto, from Solopaca, Benevento, came to American in 1895. A stonemason in Italy, he opened a barbershop in 1900 at 2051 South Front Street. He created a new type of perfume called Acqua di San Filippo that was based on cinchona. He sold the best barber supplies in America, according to *L'Opinione*. (Courtesy of Baldi family collection.)

Biagio Penza, who had his business at 919 Federal Street, was born in Casalvelino, Salerno, in 1856. He immigrated in 1881 with many of his relatives. Penza saved by putting aside and bought a horse and cart. He opened a wholesale store, and his son Tony helped run the business. The elder Penza was a founder of the Societa of San Biagio and was also the treasurer. He owned several properties and had a fortune of several thousand dollars. He lived next door to his store at 921 Federal Street. (Courtesy of Baldi family collection.)

Antonio Scarpa, who lived at 939 South Tenth Street, was from Pollica, Salerno. He came to America in 1883 and worked as a blacksmith until 1890, when he became a wholesaler in the lucrative banana trade. Scarpa was the most successful banana dealer in the neighborhood of Little Italy. He sold them to stands and pushcarts. Another man in the banana business was Giuseppe Rago, from Terranova Da Sibari. (Courtesy of Baldi family collection.)

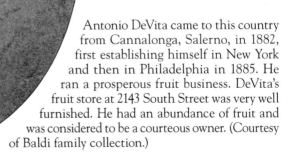

Antonio DeVita came to this country from Cannalonga, Salerno, in 1882, first establishing himself in New York and then in Philadelphia in 1885. He ran a prosperous fruit business. DeVita's fruit store at 2143 South Street was very well furnished. He had an abundance of fruit and was considered to be a courteous owner. (Courtesy of Baldi family collection.)

Magliano Antonio was born in Campagna in 1862. He studied music and was *caporale* (director) of several bands. He came to America in 1886 and was the director of the Neapolitan Band at Union Park in Wilmington, Delaware. Antonio had great success with the Roman Imperial Band at Washington Park in Newark, New Jersey. He lived at 1206 South Tenth Street. (Courtesy of Baldi family collection.)

Luigi Tomasco lived at 424 South Second Street. He was born in Casalvelino, Salerno, in 1862 and came to America in 1881. Tomasco was a fruit and vegetable vendor and, with his savings and his ingenuity, he was able to open a wholesale fruit store. (Courtesy of Baldi family collection.)

Born in Salento, Salerno, in 1850, Salvatore Zerillo lived at 735 Carpenter Street. He came to America in 1880 and ran a grocery store that had been established in 1870. (Courtesy of Baldi family collection.)

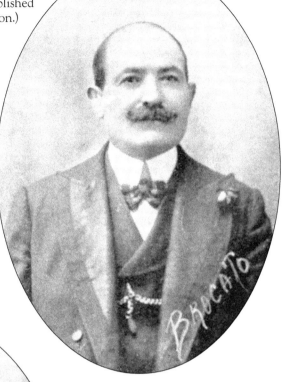

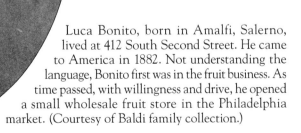

Luca Bonito, born in Amalfi, Salerno, lived at 412 South Second Street. He came to America in 1882. Not understanding the language, Bonito first was in the fruit business. As time passed, with willingness and drive, he opened a small wholesale fruit store in the Philadelphia market. (Courtesy of Baldi family collection.)

Sal Pauciello was from Giffoni Vallepiana, Salerno. He served in the Italy army's Bersaglieri. In 1883, he immigrated to New York. After two days, he came to Philadelphia. Pauciello was a milk dealer. His store was located at 808 Catherine Street. (Courtesy of Baldi family collection.)

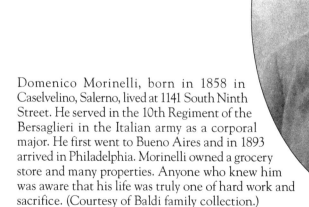

Domenico Morinelli, born in 1858 in Caselvelino, Salerno, lived at 1141 South Ninth Street. He served in the 10th Regiment of the Bersaglieri in the Italian army as a corporal major. He first went to Bueno Aires and in 1893 arrived in Philadelphia. Morinelli owned a grocery store and many properties. Anyone who knew him was aware that his life was truly one of hard work and sacrifice. (Courtesy of Baldi family collection.)

Catello Crusculo lived at 1414 Hicks Street. He was the president of Societa Mutuo Soccorso Bersaglieri La Marmora. Crusculo was from Castellamare di Stabia, Salerno. (Courtesy of Baldi family collection.)

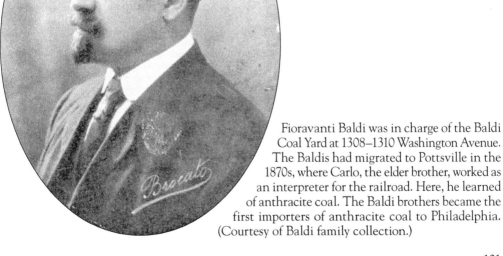

Fioravanti Baldi was in charge of the Baldi Coal Yard at 1308–1310 Washington Avenue. The Baldis had migrated to Pottsville in the 1870s, where Carlo, the elder brother, worked as an interpreter for the railroad. Here, he learned of anthracite coal. The Baldi brothers became the first importers of anthracite coal to Philadelphia. (Courtesy of Baldi family collection.)

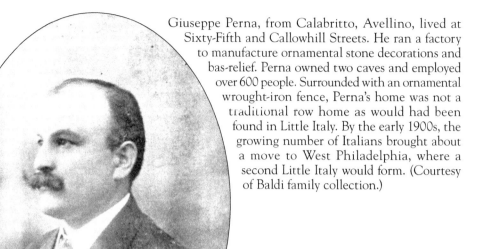

Giuseppe Perna, from Calabritto, Avellino, lived at Sixty-Fifth and Callowhill Streets. He ran a factory to manufacture ornamental stone decorations and bas-relief. Perna owned two caves and employed over 600 people. Surrounded with an ornamental wrought-iron fence, Perna's home was not a traditional row home as would had been found in Little Italy. By the early 1900s, the growing number of Italians brought about a move to West Philadelphia, where a second Little Italy would form. (Courtesy of Baldi family collection.)

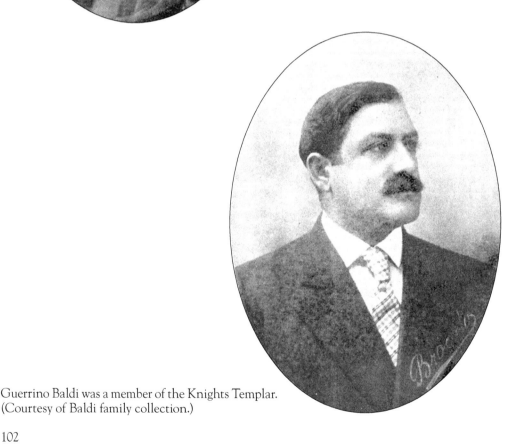

Guerrino Baldi was a member of the Knights Templar. (Courtesy of Baldi family collection.)

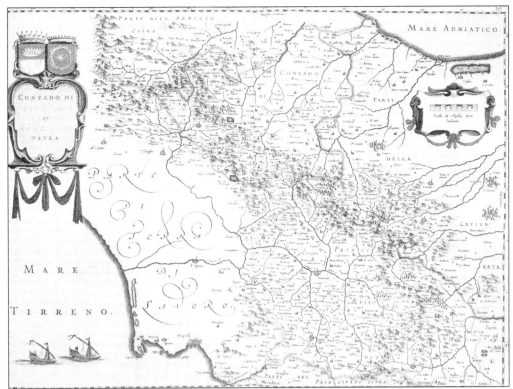

Abruzzo is the northernmost region of Southern Italy. It is to the east of Rome. In the 19th century, the Abruzzi was comprised of Abruzzo and Molise and included the provinces of Acquila, Teramo, Chieti, and Campobasso. Many Italians in Philadelphia came from Campobasso and Chieti. (Author's collection.)

Celestino Ambrosini was born in 1858 in Chieti. As a kid, he worked in barbershops in Italy. He immigrated to the United States in 1885. In his shop at 802 South Eighth Street, he employed four barbers. The chairs were the latest model at the time, and he had marble sinks and electric illumination. His employees saw him as a father, not a padrone. He was proud to be Abruzzese. (Courtesy of Baldi family collection.)

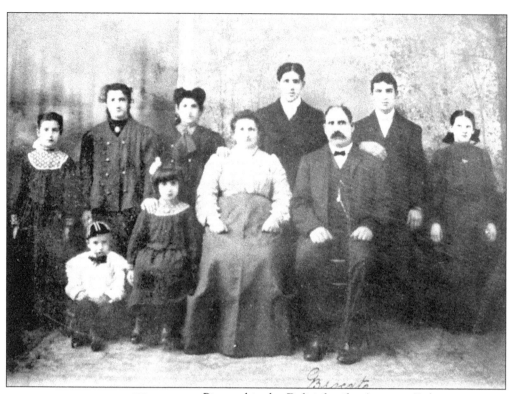

Pictured is the Delisi family. Antonio Delisi ran a store at 1000 South Eighth Street. He and Luisa Delisi immigrated to the United States in 1887. Antonio had been an artillery soldier in the Italian army in 1880. (Courtesy of Baldi family collection.)

Giuseppe Alessandroni DiPietro was from Capestrano, Acquila. He started with a grocery store. Feeling a need to support his paesani from Abruzzo, he opened a bank under the name of P.L. Allessandroni & Sons at 921 Christian Street in the heart of Little Italy. (Courtesy of Baldi family collection.)

Domenico Biello was born in 1854 in Monteroduni, Campobasso. He returned to Italy in 1881 and then came back to the United States in 1887, when he established a jewelry and watch repair along with his sons Michele and Giuseppe. He ran the Bank of Naples at the corner of Seventh and Clymer Streets. Biello was the president of the Italian Republican League. At the beginning of the 20th century, most Italians were Republicans. The Biello family has stayed in Little Italy for over 100 years. Clymer Street had two subsets of Italians from Monteroduni, one from the lower town and one from the upper. (Courtesy of Baldi family collection.)

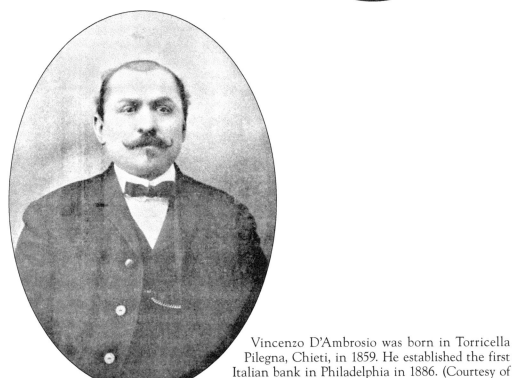

Vincenzo D'Ambrosio was born in Torricella Pilegna, Chieti, in 1859. He established the first Italian bank in Philadelphia in 1886. (Courtesy of Baldi family collection.)

Alfonso Rosa lived at 235 South Sixth Street. He was from Macerata, Marche, just north of Abruzzo. Rosa immigrated to the United States in 1882 and went first to Nevada. He studied the bel canto school of singing and toured the United States for four seasons. Rosa respected the opera composer Giuseppe Verdi and worked tirelessly to help erect the Verdi Monument. (Courtesy of Baldi family collection.)

Marco Del Vecchio was born in Venafro in 1841 and started as a tailor. His talent was so great that he opened a tailor shop before coming to America. In Philadelphia, Del Vecchio opened up a Bank of Naples branch along with Alfonso Cubicciotti. (Courtesy of Baldi family collection.)

Nicola Santilli was from Isernia, Campobasso. He came to Philadelphia in 1894 and quickly found work. Santilli had a book bindery in partnership with Fortunato Ulivieri. (Courtesy of Baldi family collection.)

This Vatican map shows the east coast of Sicily from Messina to Catania, where many of Philadelphia's early Italians originated. Some of the earlier Sicilian emigrants had left from the port city of Palermo on the west coast. Sicily is well known for its Greek ruins, especially the city of Syracuse, which was a major Greek city, equal in size to Athens and the most important city in Greek Italy. (Author's collection.)

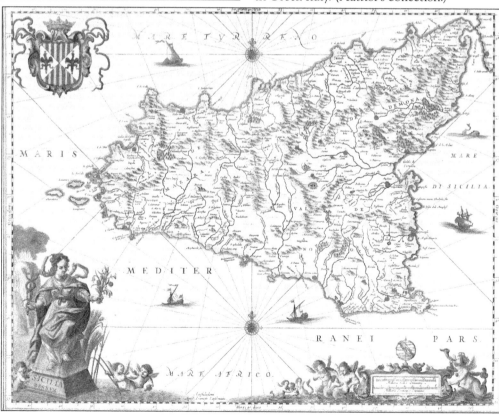

Prof. B. Pajno lived at 919 Federal Street. Born in Messina in 1877, he studied at the Academy of Fine Arts in Palermo. He then went on to Paris and Belgium before coming to the United States in 1902. Pajno was recognized as a *cavaliere* by the Italian consul. He ran an art studio at the Federal Street address. (Courtesy of Baldi family collection.)

Francesco La Torre, who lived at 704 South Seventh Street, was born in Messina in 1857. He studied to be a machinist and went to England. There, he worked on motors for boats. When he came to America, he opened a Sicilian bakery. His bread was the best quality, and La Torre was the owner of two properties on Washington Avenue. (Courtesy of Baldi family collection.)

Achille d'Orazio, who lived at 1020 South Ninth Street, was born in Civitella Messer Raimondo, Caserta. He emigrated from Italy in 1886 and establish a brewery in Philadelphia. He was the head of *una azienda*—in this case, a linen company with a capital of $16,000. D'Orazio lived above the store. (Courtesy of Baldi family collection.)

Cesare Romano was born in the province of Chieti in 1878. His family was well known in Italy for their *torrone* (nougat) of dried figs. He was the president of the Bank of Torino at 822 South Eighth Street. He sold tickets to Italy, remittance for money orders, and telegrams. He also had stone quarry in Pottstown that employed over 100 laborers. He was seen as a self-made man. (Courtesy of Baldi family collection.)

Emaneule Nardi's father, Lorenzo, was born in Decimo, Lucca, in 1819. The family was responsible for helping to found the Columbus Society. Emaneule was also the president of the Legione Umberto, named after the king of Italy. Lorenzo first went to France, where he married, and in 1852, he arrived in Philadelphia. Lorenzo came up with the idea of hair forms for men and women out of chalk, instead of wood, which was previously used. A great lover of Italy, Emaneule was one of the founders of the Societa Unione e Fratellanza Italiana, the first in Philadelphia and second in the United States. Emaneule was also the founder of Legione Umberto. He was also part of the Columbus festivities in 1876 and all demonstrations for in honor of Italians. Lorenzo died in 1892. (Courtesy of Baldi family collection.)

Fortunato Ulivieri born in Livorno, Tuscany. He worked with typography at Ulivieri & Fagiolini in Livorno. He came to America in 1899 and quickly became a musician in what an article in *L'Opinione* calls "the best Italian band," which annually played in tournaments around the country. Ulivieri united with Nicola Santilli and opened a book bindery. (Courtesy of Baldi family collection.)

Casimiro Alleva lived in Norristown. He came to join his brother Diamante. Casimiro was the secretary of Club Indipendente. He picked fruit in New Jersey, working hard and sacrificing. Italians were very successful at growing mulberries, blueberries, and raspberries. They had many farms in Vineland and Hammonton, New Jersey. Casimiro and others went there in the summer. The fruits of their labor would be sold at market in Philadelphia. Eventually, after all his hard work, Casimiro was able to open a grocery store and bakery. He was the president of Mutuo Soccorso Italiana. (Courtesy of Baldi family collection.)

Vittorio Giannini lived at 728–730 South Seventh Street. He was born in Ponte all'Agna, Lucca, and went to England and Belgium to make figurines. In 1881, he came to the United States and worked with the Lucchesi family. In 1893, he won an award for the figurines he made at the Chicago World's Columbian Exposition. (Courtesy of Baldi family collection.)

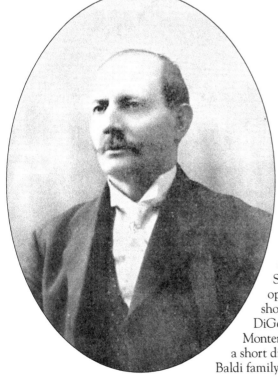

Gennaro DiGenova was from Montella, Avellino. He was the president of the Banca D'Italia, at the southeast corner of Seventh and Pemberton Streets. He was a farmer's son who started in the fruit produce business when he came to the United States in 1876. By 1884, he acquired a license to sell beer and liquors and ran a store at 810 South Street and later at 700 Bainbridge Street. By 1895, he was doing so well that he opened the bank. DiGenova was assisted for a short time by Salvatore Vernacchio and then by DiGenova's wife, Benedetta Silvestri, from Tobia, Monteroduni, Campobasso. Most of her paesani lived a short distance away on Clymer Street. (Courtesy of Baldi family collection.)

Giovanni Salotti was from Fosciandora. He came to America in 1881 but returned to Italy to marry. He returned to the United States in 1888, establishing himself in Philadelphia. Salotti started with a small fruit store. As time progressed, he added cigars and confectionery. His store was two blocks north of Market Street and had a lot of traffic from American customers. (Courtesy of Baldi family collection.)

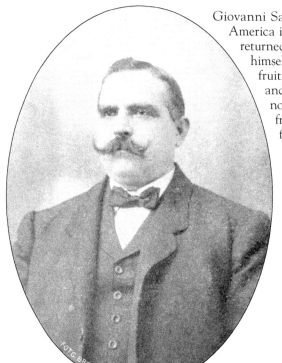

Nazareno Monticelli, from Pianella, Teramo, lived at 1022 South Ninth Street. He was born in 1871 and was a carabiniere in Italy for five years. He was known in Mexico and Canada and developed perfumes, medicine, and oil. (Courtesy of Baldi family collection.)

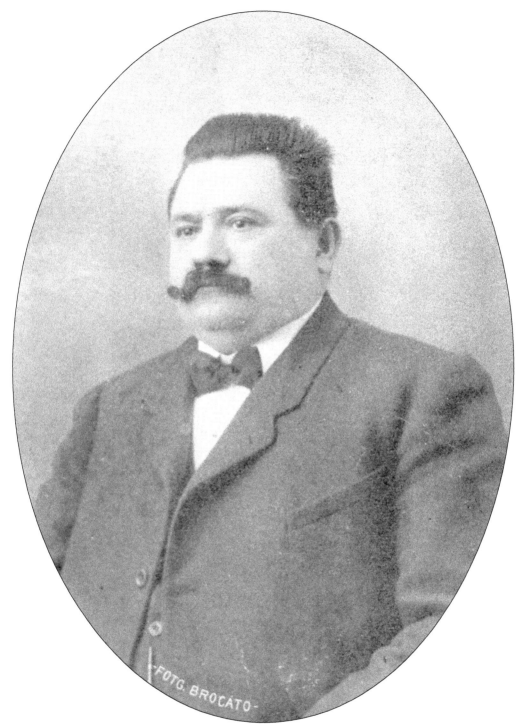

Nicola Pessolano was born in 1863 in Atena Lucana. He came to this continent in 1879 and opened an elegant brewery at the southeast corner of Sixth and Fitzwater Streets. He was considered to have a heart of gold and was a member of many mutual aid societies. Three words used to describe him were *honest*, *hardworking*, and *patriotic*. (Courtesy of Baldi family collection.)

Paolo Pomero was born in 1864 in Vercelli, Piedmont, in Northern Italy. When called to the Italian army in 1884 at the age of 20 for his two years of compulsory service, he left his work tuning pianos. In 1896, he had the idea to come to America to improve his luck. Pomero had two piano factories with 24 employees who loved him. (Courtesy of Baldi family collection.)

G.S. Piscitelli, who lived at 1054 Passyunk Avenue, was from Pietrafitta, Cosenza. He arrived in 1896 and went to Heald College in San Francisco and Columbia College of Philadelphia. Piscitelli was a representative of the Marconi Wireless Telegraph Company. He and his brothers ran the Italian-American Bank of the Piscitelli Brothers. A member of various companies, he had a wireless telegraph in his office to communicate with steamers that were out at sea. (Courtesy of Baldi family collection.)

Giovanni Jaffola, who lived at 767 South Eight Street, was born in Capestrano, Aquila, in 1850. He worked as a mason before coming to America in 1883. Here, he did any work he could find in the beginning to live. After learning English, he returned to work as a contractor. He was also the owner of a grocery store at 667 South Eighth Street. (Courtesy of Baldi family collection.)

Ten

CHURCHES

The two Italian parishes serve to keep the Italians united here and to conserve their national character. The rector of one of the parishes told the author: "In order to maintain in our countrymen the Catholic religion, it must be offered in Italian. And to remain Italian, we need a school of our language." Annexed to the two churches are parochial schools able to handle more than 500 students. In 1870, Fr. Antonio Isoleri was pastor of St. Mary Magdalen de Pazzi. He also ran an orphanage with 30 girls. The other parish, Our Lady of Good Counsel (founded in the 1898 by Italian Augustinians), has a kindergarten. By 1901, there were 1,596 baptisms between the two churches. The Italian government calculated that one birth represented 44 living persons. So it determined the population of Little Italy at that time to be 70,224. The instruction in these institutions—half in English and half in Italian—is given by Franciscan nuns. They receive help from the Italian Ministry of Foreign Affairs in acquiring textbooks and scholastic materials. Both the annexed churches and institutions, worth altogether approximately $175,000 at the turn of the 21st century, were erected and are maintained nearly exclusively with Italian money—and not with bequests or gifts from the rich but through the means of modest and anonymous workers. There were four priests and 10 nuns serving the early Italian community.

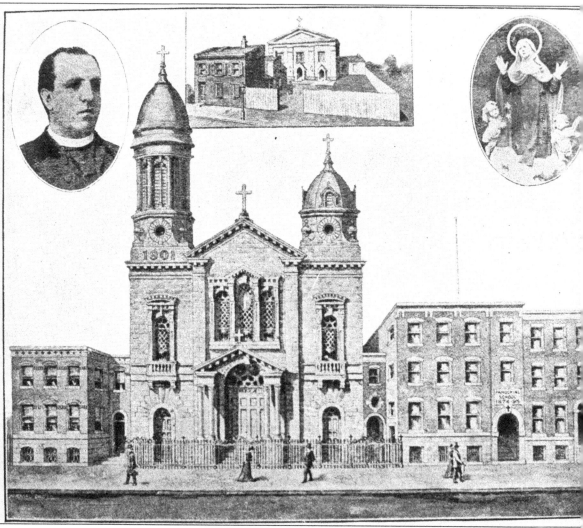

The original church, pictured here, was bought for the Italians by Bishop John Neumann in 1852. Formerly a Methodist church, it was given the name St. Mary Magdalen de Pazzi after a saint from the Tuscan region. Fr. Gaetano Mariani is listed as the first pastor. He arrived in America in 1818, along with other priests. He was from Tuscany, unlike the later pastor Father Isoleri, who was from Genoa. Notice the second cupola on the right; this was lost in a fire in the 1930s. (Courtesy of St. Mary Magdalen Church.)

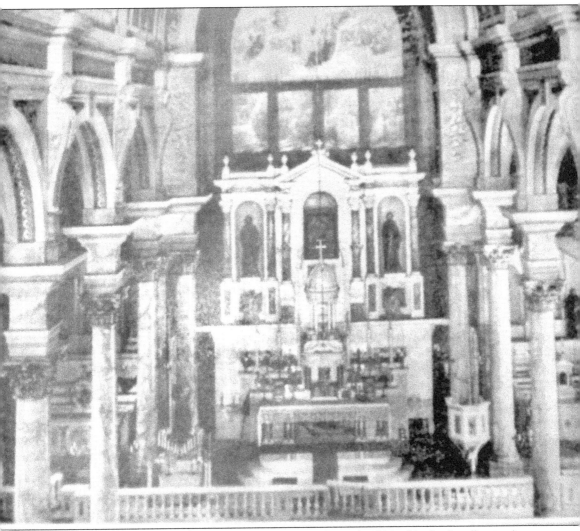

The interior of St. Mary Magdalen Church is pictured in the early 1900s. (Author's collection.)

Here is a copy of the original insurance policy for St. Mary Magdalen Church. Note that John Rogers (Giovanni Raggio) signed for the Right Reverend John Neumann, then bishop of Philadelphia. (Courtesy of St. Mary Magdalen Church.)

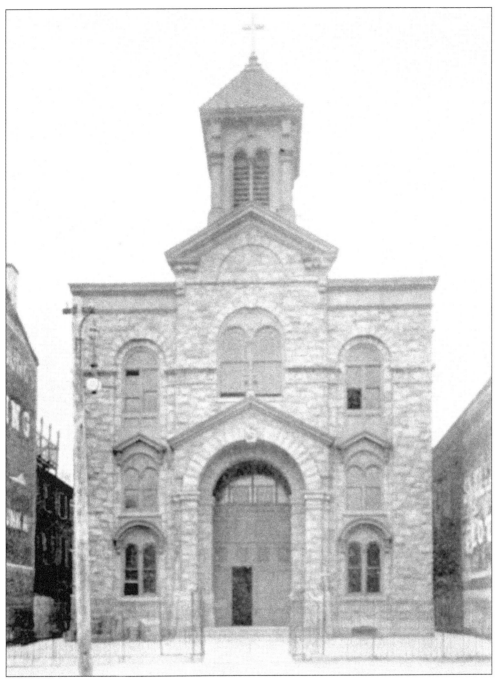

In 1894, the Chapel of Our Lady of Pompeii was opened by priests (and brothers) Loreto and Clemente Cardarelli at the northeast corner of Sixth and Fitzwater Streets. It was not recognized by the diocese. The Italians went to the chapel until 1898, when the diocese opened Our Lady of Good Counsel (pictured). The building used was the former school of St. Paul's. The church had an ornamental three-story entrance, as seen here. The school was above. At the rear of the church on Montrose Street was the sacristy. When the church was formed, there were still civil court actions attempting to resolve Our Lady of Pompeii. (Author's collection.)

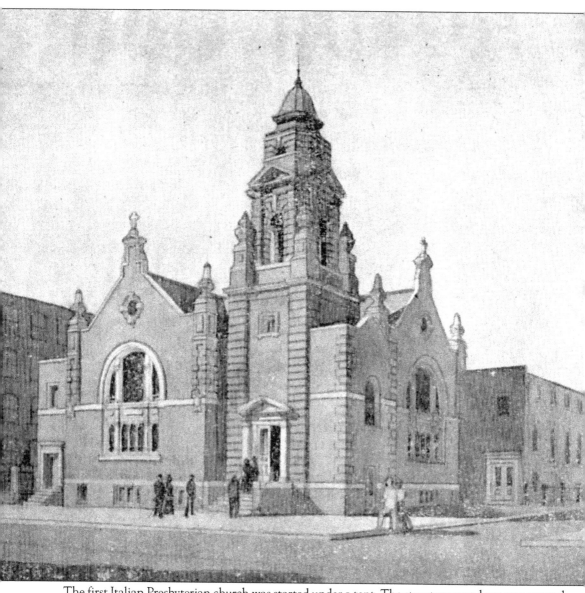

The first Italian Presbyterian church was started under a tent. The structure seen here was opened in 1903. Its first leader was Michele Nardi. He was followed by Agide Pirazzini, then Felix Santilli, and then Arnaldo Stasio. The church was located at the southwest corner of Tenth and Carpenter Streets. The goal of the leadership was to convert many of the Roman Catholics. In 1892, a Dr. Macgregor, who was a Presbyterian pastor, said Little Italy was the "demons den and a rat trap." (Courtesy of Baldi family collection.)

Carlo Donato, from Maida, Catanzaro, is pictured here as a priest for Mary Magdalen Church. He changed his mind while studying and decided to marry. He married Bennedetta Gandolfo, the daughter of Colombo Cuneo and Gioachino Gandolfo. Donato's father ran the Banca Mediterraneo at 843 South Eighth Street. (Courtesy of Colomba Donato Stabeno.)

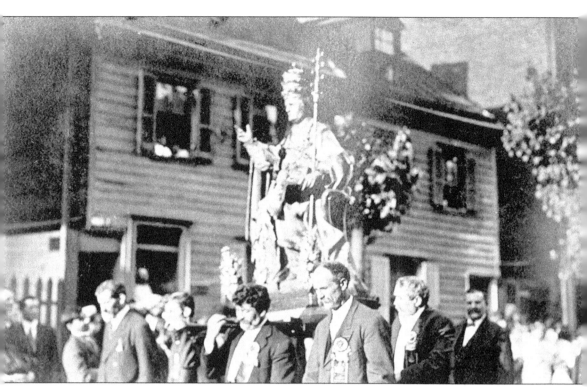

This parade of saints in Little Italy includes an effigy of the pope. The pope at the turn of the 20th century was Leo XIII, who died in 1903. He holds the record of being the oldest pope and reigned until he was 93. However, he did not have the longest papacy. (Author's collection.)

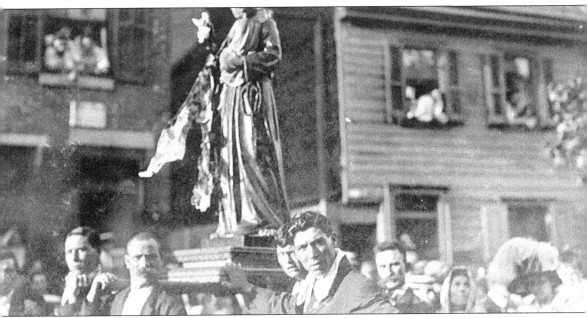

The parade of saints in Little Italy was lengthy. St. Joseph and the pope were among those carried through the streets. (Author's collection.)

Visit us at
arcadiapublishing.com

CPSIA information can be obtained
at www.ICGtesting.com
Printed in the USA
LVHW061640291122
734259LV00007B/449